How to Draw Trees

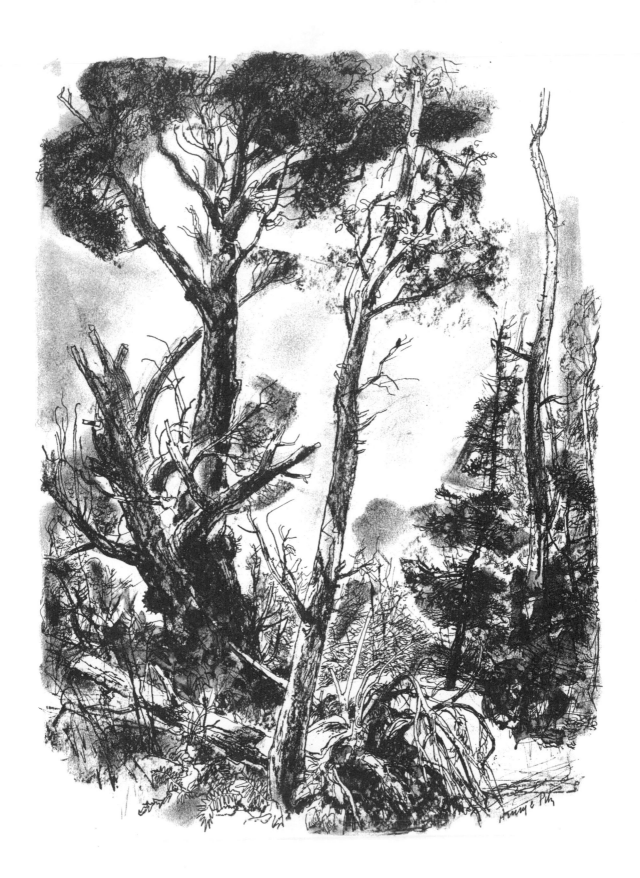

How to Draw Trees

Revised, Enlarged Edition of *Drawing Trees*

By Henry C. Pitz

WATSON-GUPTILL PUBLICATIONS, New York

PITMAN PUBLISHING, London

To Julia and Bill

Copyright © 1956, 1972 by Watson-Guptill Publications

Published 1972 in the United States and Canada by Watson-Guptill Publications,
a division of Billboard Publications, Inc.,
1515 Broadway, New York, N.Y. 10036

Published simultaneously in Great Britain by Pitman Publishing Ltd.,
39 Parker Street, London WC2B 5PB
(U.K.) ISBN 0-273-00040-3

Library of Congress Cataloging in Publication Data
Pitz, Henry Clarence, 1895-
 How to draw trees.
 First ed. published in 1956, under title: Drawing trees.
 1. Trees in art. 2. Drawing—Instruction
 Bibliography: p.
1. Title.
NC810.P5 1972 743'.7 77-187916
ISBN 0-8230-1441-X

Manufactured in U.S.A.

First Edition, 1956
 First Printing, 1956
 Second Printing, 1964
Revised, Enlarged Edition, 1972
 First Printing, 1972
 Second Printing, 1974
 Third Printing, 1976
 Fourth Printing, 1978

Preface

As this introduction is being written, outside the studio window a first fall of wet snow has covered the ground and clings to the branches of the barren trees. With an overcast sky, the scene is essentially a black-and-white picture, in which the tracery of the trees is enhanced by this change in nature's cycle. A few short weeks ago, the same view was a mass of fall color. Lemon yellow and vermilion vied with dark brown and dense green. The trees could not be denied.

When Winter passes into Spring, the slumbering trees, that presently silhouette their naked forms, will blossom out in light green leaf again. And then, grow and richen, until in Summer's heat their cool shade will cast long shadows.

From the beginning of time, trees have occupied a prime position in the life of man. They have provided him with food, with shelter, and even with transportation. In his spiritual life they have often been used as symbols; they have played a part in both his legend and his history. Man has planted them, and when it served his purpose, he has cut them down; he has venerated them on the one hand and destroyed them wantonly, on the other. From his cradle to his grave, the tree has been his silent friend. They were here before him and in the end they will be the last breathing things on earth to die.

The tree first appeared as a conventional design in the history of art as, witness, the palm in Egyptian decoration — sculptural and pictorial. When we come to the Gothic period in Europe, we find it appearing in stained glass, in bas-relief, in illuminated manuscript books, but still conventional in form. The early Renaissance masters, particularly the fresco and tempera painters, introduced the tree in their compositions but only as a prop. By the time the high Renaissance was reached, and drawing and painting from a technical standpoint had gained its notable facility, the painter was able to deal with the tree in dimension and individuality, comparable to his success with the human figure. But still trees were used principally as a foil for figure compositions. With the emergence of Nicholas Poussin (1594-1665) and Claude Lorrain (1600-1682) landscape painting became an independent art, paving the way for such later masters as Hobbema, Constable, Corot, Cezanne, and our own Moran and Inness, to mention a few.

For the artist to paint pictures of trees, whether they become his dominant

motif or serve as a background for architecture or figures — before he can paint them with any degree of success — he must first learn something of their essential structure, the individual characteristics of particular trees, their textures, their barren and leafed versions. How can this be achieved except by going directly to nature and learning to draw them?

Among American artists it would be difficult to find a more consistent draughtsman of trees than Henry Pitz. Over a long and distinguished career as illustrator, painter, printmaker, and teacher, he has made countless hundreds of tree drawings. These fill his sketchbooks only to reappear in his illustrations and paintings, and always with an authority that could only be gained by familiarity and searching observation.

In this book — dedicated to the thesis that for artists to know trees, they must learn to draw them — Mr. Pitz has provided his readers with a manual, which, if taken to heart, cannot help but induce self-study. Both in his discussion and in his fulsome illustration, he imparts his own infectious enthusiasm for his subject. Like the man, who, in planting the proverbial acorn, confidently expects an oak tree to grow!

By an orderly fashion, successive chapters show us how to begin tree drawings, what to attack first, how to proceed from general to specific form. The variety of media he uses invites us to explore pencil, charcoal, pen and ink, wash, and combinations of these. It is not a book to read and put away but rather the kind to digest and apply.

No less important in the book's over-all worth is the section devoted to the Gallery of Examples. Here we find a number of drawings, ranging in time from the past to the present, with pertinent commentary to increase our appreciation. Finally, a check list of other books on trees is appended for those, who, having found in this a studio handbook, may wish to extend their study by editorial reference.

NORMAN KENT

Contents

THE GREEN, GROWING WORLD 11

THE TREE SKELETON 13

TREE FOLIAGE 16

TREE TRUNKS 20

BOUGHS AND BRANCHES 24

DRAWING TECHNIQUES 28

PENCIL AND CRAYON 30

PEN AND INK 34

DRYBRUSH AND SPLIT-BRUSH TECHNIQUES 40

CHARCOAL 44

FOUNTAIN BRUSH 48

MIXED MEDIA 52

SOME FAMILIAR TREES 56

OAKS 58

ELM 62

BIRCH 66

EVERGREENS 70

WILLOW 74

MAPLES 78

SYCAMORE 80

BALD CYPRESS 82

DOGWOOD 84

ROOTS, STUMPS AND DEAD TREES 86

SKETCHING SUGGESTIONS 90

FOREGROUND, MIDDLE DISTANCE AND DISTANCE 92

TREES IN LANDSCAPE 94

TREES IN MIST AND FOG 96

TREES AND SNOW 98

TREES AND RAIN 100

TREES AND WATER 102

THE FALLEN TREE 104

THE GROUND UNDER TREES 106

TREES AND PEOPLE 108

TREES AND PEOPLE: DECORATIVE INTERPRETATION 110

TREES IN ILLUSTRATION 112

TREES IN THE DIRECTION OF THE DECORATIVE 114

TREES IN DECORATION 116

TREES AND RHYTHM 118

THE IMAGINARY TREE 120

TREES AS LINEAR PATTERN 122

TREES AS DECORATIVE PATTERN 124

TREES AS ABSTRACT PATTERN 126

A GROUP OF TREE DRAWINGS 128

A GALLERY OF EXAMPLES BY VARIOUS ARTISTS 133

 RONALD SEARLE 134

 STOW WENGENROTH 136

 ALBERT GOLD 138

 ANDREW WYETH 140

 OGDEN PLEISSNER 142

 NORMAN KENT 144

 LYLE JUSTIS 146

 ERNEST WATSON 148

 TED KAUTZKY 150

 CLAUDE LORRAIN 152

 CARL PHILLIP FOHR 154

 A. WATERLOO 156

LIST OF SELECTED BOOKS 158

How to Draw Trees

The Green, Growing World

The green, growing world is a natural source of picture material. It offers the artist an inexhaustible treasure house of shapes, forms, colors, textures and rhythms; a treasure house that has been merely tapped by the long generations of artists who have preceeded us. But it is more than an opportunistic store of picture and design motifs. It is the world from which we draw our strength, more basic and eternal than the cities we build. We ignore it at our peril.

But ignore it we do. Whole tribes of artists have their being in comfortable prisons of steel, asphalt and concrete. Their horizons can almost be touched by the hand; the sky must be searched for, scrap by scrap, and weather comes through a duct. Steel, asphalt and concrete breed an art of colored geometry. Meanwhile the green world bides its time. It knows it cannot flourish on steel, asphalt and concrete, but neither can man.

Nature has always been the great invigorator, and man has always turned back to her either in wisdom or in panic. Signs are not wanting that we are on the eve of a new return. There are still enough seeds in nature for countless of the future's masterpieces. Some artists are looking for them. Some will find them in the miraculous form of the tree.

Certainly one of the noblest things in the growing world is the tree. It is not only an amazing living mechanism, but a constant delight to the eye, and visual delight is the life of art. An artist could not wish for more inviting, challenging and inexhaustibly refreshing material. Whether he wishes to use this material in the strictest realistic way, or as a point of departure into the world of invented abstract forms, here at his hand is the stuff that can set the mind fermenting and the fingers performing.

This wonderful material is within reach, but we must grasp it. To make it our own, to acquire some command of its resources, we must pay a price of interest, effort and study. The rewards of that study can be very great. Our concern may be an intermittent, avocational thing, or a lifetime dedication; in either case the compensations are likely to be proportional to the effort.

The principal means at our disposal are constant and intelligent observation, and diligent recording. They must go together. Aimless and lazy drawing will not achieve much; observation by itself will not teach the hand to find graphic symbols for the things observed.

Sometimes students are appalled when they are told that command comes only from making hundreds of drawings. And yet this mountain of work is not difficult to accomplish, once true interest is kindled. Where there is a deep-seated concern, drawing will follow drawing as a matter of course. Such occupation, even by the most accomplished, always requires concentration and effort, but once some degree of competence is gained, it can become a deeply joyful experience.

One of the great satisfactions of drawing comes from the necessity to scrutinize both broadly and sharply, to penetrate imaginatively below the skin of things, in order to discover the underlying forms. So drawing brings its own reward in the form of enhanced perceptions.

Although when all is said, we learn to draw by drawing, the will to draw can be kindled from many sources: the contemplation of the work of other artists, association with fellow creative minds, contact with good teachers, the reading of books. The student will instinctively reach out for those things that will warm and strengthen his groping search, his awareness of wonder, his concern with methods and media, his ache for achievement.

His particular concern with tree forms is likely to lead him into a lifetime love for them, to urge him into a study of their astonishing past and of the order behind their confusing diversity. And surely he will come to consider them an entrance into the greater world of all natural forms. He will see them as an important element in the vast plan of nature, and even the merest scrap of landscape will convey to him a history of incredible survivals.

A short list of selected books on tree growth and structure, also on various graphic means of depicting them will be found on the last pages of this book. An artist does not have to become a botanist to draw trees, but some idea of the mechanism of the tree can save him some fumbling. A certain number of artists seem to be born with a suspicion of books, and yet few have been crushed by weight of knowledge.

12

The Tree Skeleton

A tree has a skeleton. It is the most important part of the tree, for the cloak of foliage is a seasonal thing, but the skeleton is always there during the life of the tree and for a while afterward. Part of the tree skeleton is unseen, underground in the root system. The radiating structure of trunk, branch and twig above ground is the principal concern of the artist, for the size, shape and movement of that structure rule the form and character of the tree.

The warm months of the year are the popular ones for outdoor sketching and yet, late autumn, winter and early spring are better times for beginning the study of trees, for the skeleton can be scrutinized without the distraction of its foliage. It is less difficult, then, to discover the basic similarity in all tree structure, how its trunk rises from its root system into the air, and how the web of bough, branch and twig spreads up and out, seeking the light. The modifications, which each species brings about in the basic pattern, can be studied and even the minor characteristics which make each individual tree different from all others — differences at least as marked as those of human beings.

Many trees have such characteristic skeletons that they can be quite readily recognized with a little practice, others are so similar that even an expert botanist must look for other means of identification.

In the margin and on the opposite pages are drawings of some tree skeletons. Family characteristics can be detected in these underlying armatures: the graceful, arching, inverted vase shape of the Elm, the ragged irregularity of the Willow, the stout and massive quality of the Oak, and the angular impressiveness of the Sycamore. There are many others, for instance, the quivering column of the Lombardy Poplar, the light trunk and horizontal branching of the Honey Locust, and the towering shaft of the Tulip Tree, but all these and others will become familiar as one draws and studies. The important thing is to begin drawing and observing. The act of drawing will begin leaving a deposit of visual impressions in the mind, then some books on trees may be consulted to help with the other methods of identifying species, but if there is any love for the subject in the artist this will come about naturally. There is no need to become even an amateur botanist unless one wishes, but it will help.

SYCAMORE

ELM

POPLAR

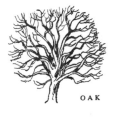

OAK

WHITE WILLOW

MAPLE

WEEPING WILLOW

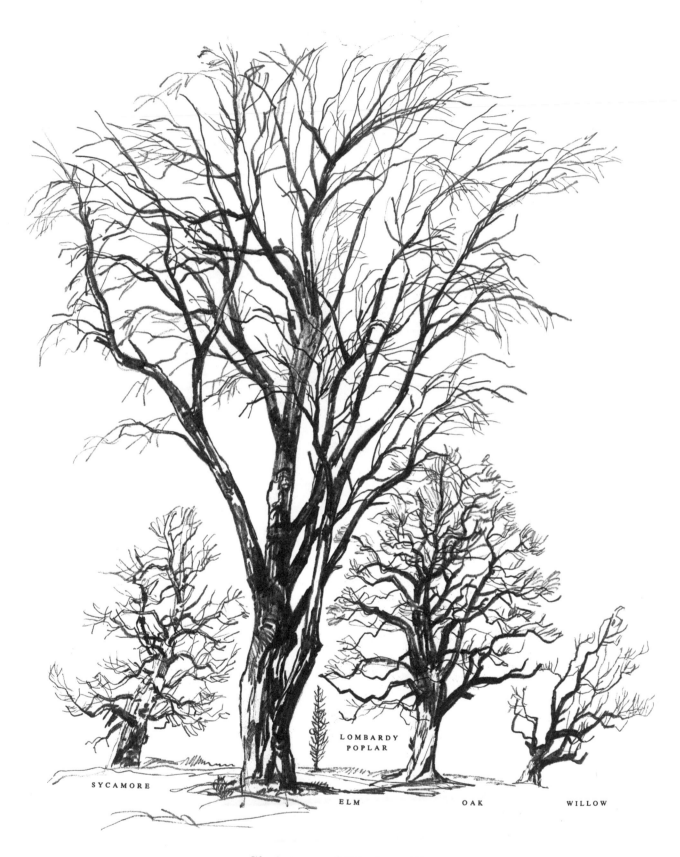

SYCAMORE

LOMBARDY POPLAR

ELM OAK WILLOW

Skeletons of Various Trees

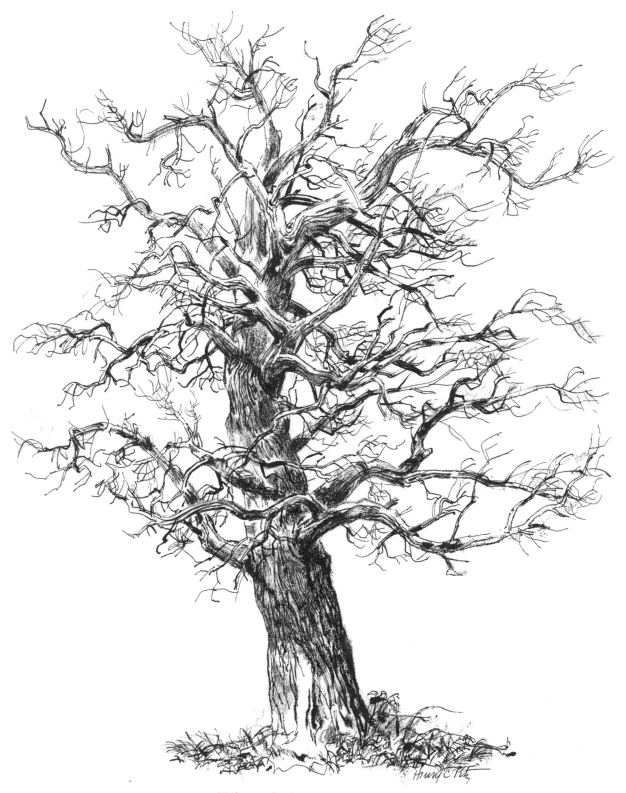

White Oak
Drybrush on illustration board

15

Tree Foliage

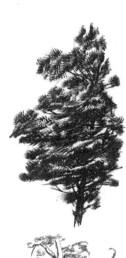

Tree foliage, except for that of the Evergreens, is a part-time garment, a garment that begins as the thinnest, most impalpable of veils, grows thicker and heavier day by day to midsummer weight, and then shreds away leaf by leaf. Artists have long realized that the transition periods of the waxing and waning of leafage are of particular interest to them, the indescribably tender greens of spring and the muted browns to blazing reds of autumn. So if we hope to get the most from our study of trees, we must watch and draw them the year around. The appearance of the foliage masses, coincides with the *comfortable* sketching months, so there are many artists who have never drawn a naked tree.

Foliage masses are baffling to many because they do not suggest a comfortable solidity and because they suggest infinite detail. Except in meticulous, close-up compositions, the individual leaves should not be searched out. Only large and important masses of leafage should be looked for and fortunately many tree masses can be simplified into one or more geometrical forms. In looking for these, it will help to view the tree in a strong, rather low side light.

Not all trees can be reduced to the simple cone of a well-shaped Fir or the inverted bowl of a symmetrical Elm, for instance, but must be solved in terms of a large number of cubes, spheres, cones, discs, and/or saucer shapes, interlocked and cutting through each other. And some trees are so irregular that it would be a waste of time to foist a complex geometric system upon them.

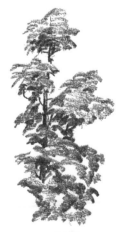

Once the big masses have been blocked out, try to indicate the tone of their relative lightness or darkness. Each artist of individual stature works out his own way of indicating such tones, but it might be well for the beginner to try to follow with brush, or with point, the *direction of growth* as it radiates outward from the trunk and main branches, (the downward droop of the Weeping Willow seems to call for a different direction of stroke from the upward and outward thrust of the Horse Chestnut). At the same time, the beginner should try to convey the *character* of the foliage, its density or thinness, its feeling of weight or lightness, (for instance, the Norway Maple is heavy and compact by comparison with the lacy, spray-like quality of the Locust).

The holes in the foliage masses should be drawn with great care and the branches visible in them should be indicated, not as a collection of haphazard

sticks but with regard to their natural radiating habits. The edges of the foliage mass, too, should be studied. Some boundaries will be blurred or completely lost, others will be clean-cut and hard. The way these edges are treated is an important factor in conveying the character of a tree, the kind of light that falls on it and its distance from us.

Not all sketching should be done at a respectable distance. At times one should come close and draw sprays of foliage and individual leaves. The serious student will wish to master the complete range from the precise and detailed drawing of a single leaf to the impressionistic blur of a far distant tree.

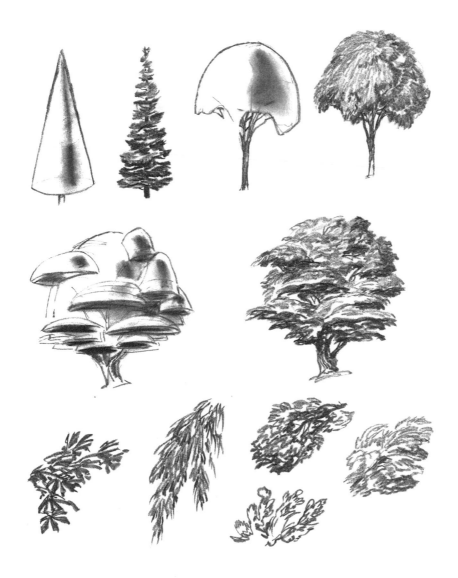

Foliage Forms

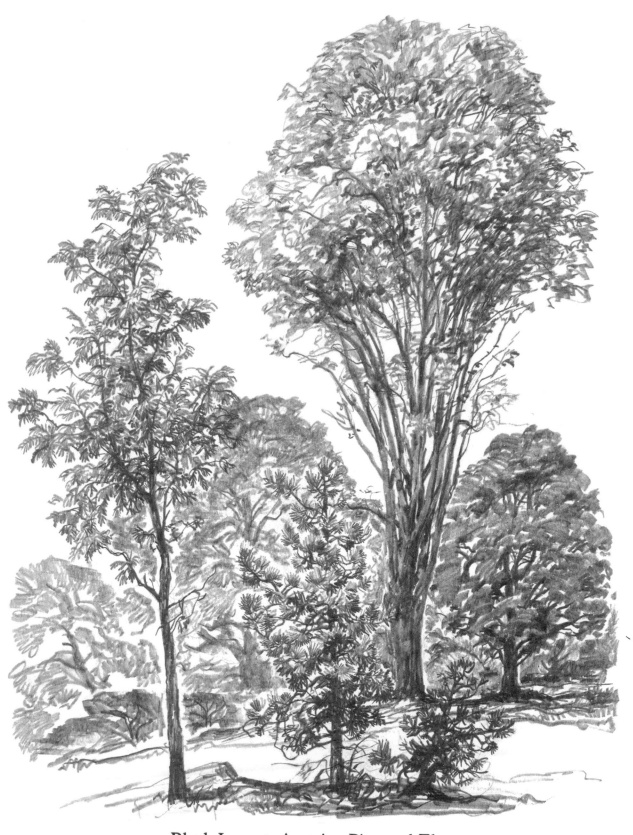

18

**Black Locust, Austrian Pine and Elm
against** Background of Oak and Maple
6B pencil on cameo paper

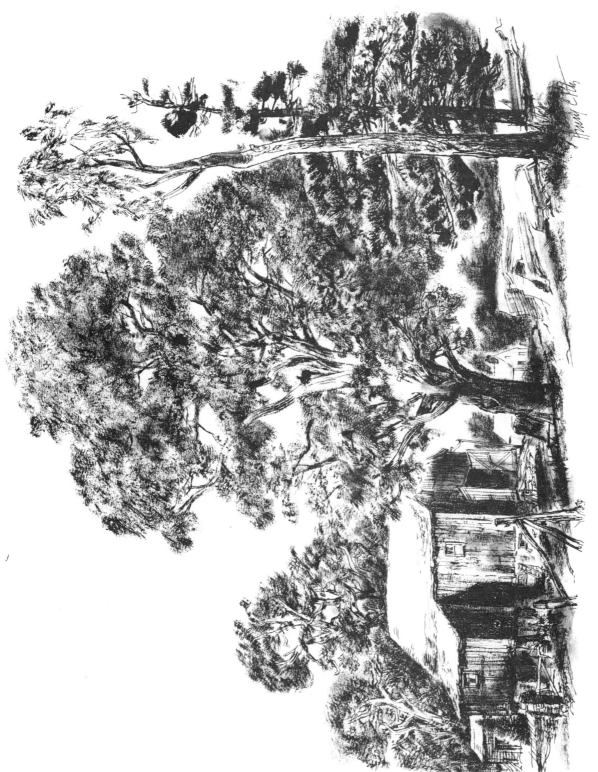

Sycamore, Oak, Black Locust and White Pine
Drybrush on illustration board

19

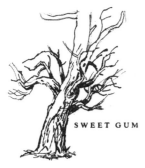

MAPLE

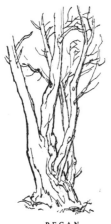

SWEET GUM

PECAN

Tree Trunks

At first thought a tree trunk seems an easy enough thing to draw, but it requires at least a little skill and a little knowledge to make it resemble something more than just a post to which a few scraps of hay adhere. Tree trunks not only have a great individuality but also a function which can be disclosed by perceptive draughtsmanship. First of all, the trunk is not a separate thing; it rises from an elaborate root system and tapers up and out into bough, branch and tree. The form is continuous.

Even though it comes into our vision only as it breaks through the earth crust, it usually gives ample hints of its union with the roots below. In general, it spreads as it enters the earth, often markedly so, and not infrequently some of the actual roots peer above the surface. On rocky, scanty or eroded soil an amazing amount of the root system may be exposed. If these things are observed and suggested in the drawing, the tree will have an anchored look. Another important thing to observe is the shadow of the trunk and the foliage above, as it spreads across the ground. If that is drawn knowingly, the tree will impart a feeling of solidity and security.

The trunks of some tree varieties have such marked characteristics as to make recognition easy. In the matter of bark color and texture, it is not difficult to identify the striped and mottled white bark of the Paper Birch, the smooth gray surface of the Beech, and the peeled and patchy bark of the Sycamore. Shape is also a valuable clue. After one has made a dozen drawings of the scored, lumpy and erratic White Willow, or the thorny silhouette of the Honey Locust, one will be able to name these varieties. But recognition is not the most important thing. It is vital to appreciate these characteristics as pictorial and design material and give them telling and meaningful expression in our drawings.

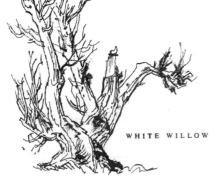

WHITE WILLOW

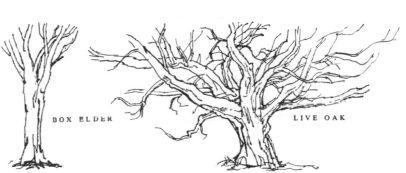

BOX ELDER LIVE OAK

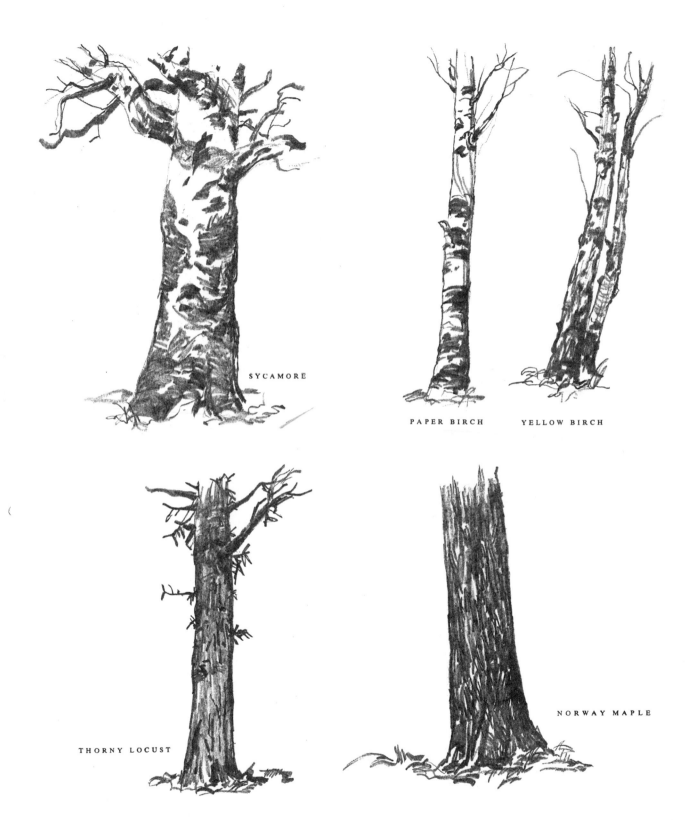

SYCAMORE

PAPER BIRCH YELLOW BIRCH

THORNY LOCUST

NORWAY MAPLE

Various Tree Trunks
6B broad-edged pencil on cameo paper

21

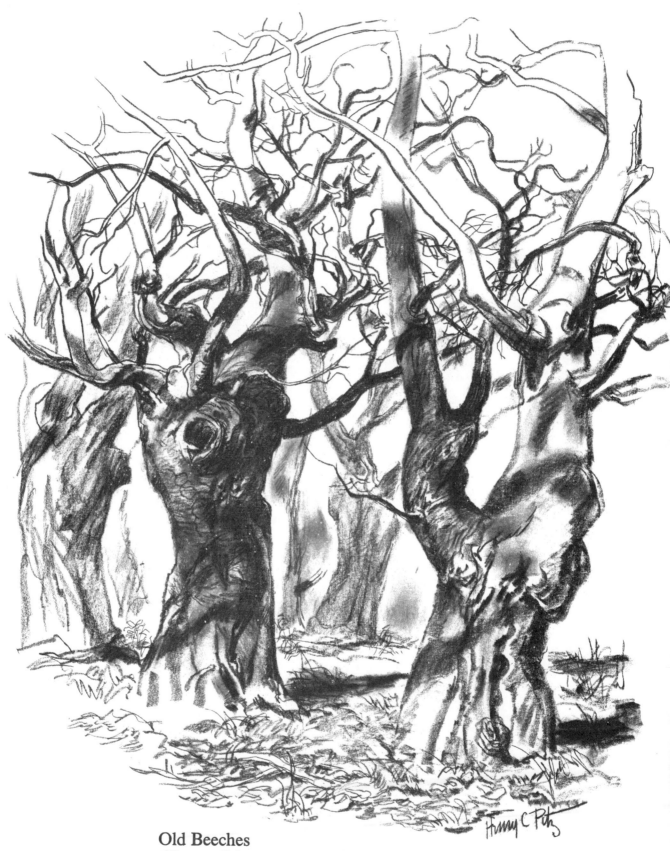

Old Beeches
6B pencil (some areas rubbed) on cameo paper

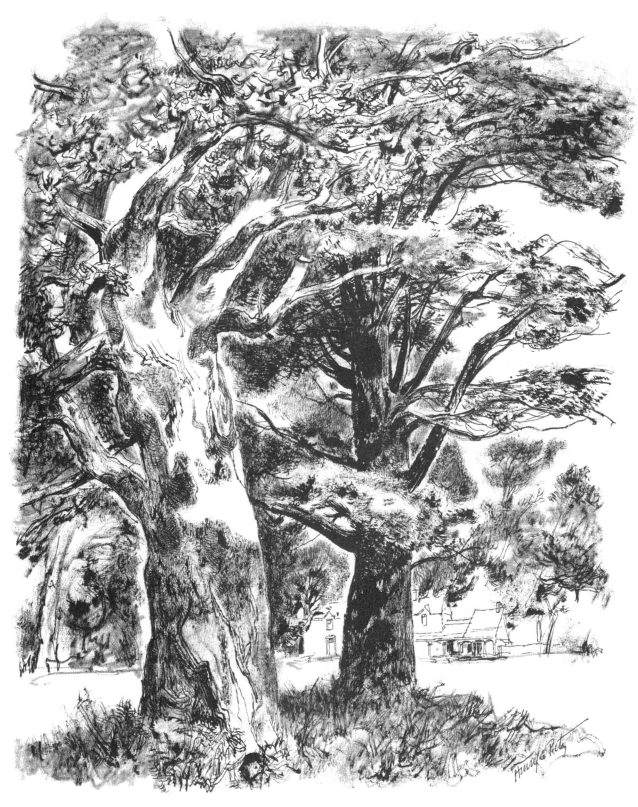

Tree Trunks
Drybrush on illustration board 23

Boughs and Branches

BOX ELDER

SHAGBARK HICKORY

SYCAMORE

One of the most important pictorial parts of the tree is the breaking out of the first boughs as the trunk rises from the ground. A great deal of a tree's character is disclosed in this area. The height of the first branching is important. Of course, all forest trees tend to lose their lower branches and we expect to find the first live branches high above the ground (the difference in form between a single specimen and a forest-crowded tree of the same variety is sometimes surprising). But some trees, like the Tulip Tree and Black Walnut tend to branch high up, and, in others, like the Beech and some Conifers, the tendency is for the lower branches to sweep to the ground.

The way the branches spring from the trunk is also important. Some tend to arch out in a graceful, flowing way like the Elm; some spring at right angles like the Dogwood; some arch up and then curve downward like a fountain as in the Weeping Willow and Cut-leaf Birch; and still others display angularity and a tendency to change direction like the Sycamore.

One problem, which many have a tendency to evade, is that of drawing branches moving toward or away from the spectator. It is true that the branches which extend out on either side of a tree are usually the more conspicuous and most of those moving away are partly or entirely concealed, but the draughtsman, who refuses to draw foreshortened branches, will have a flat drawing on his hands.

Reducing the average branch to its basic geometric form, that of a series of long cylinders, and plotting each change of direction in this simplified form, should be an aid in visualizing branch anatomy. This is demonstrated on the facing page. Another helpful device is to observe and draw the shadows that one branch casts upon another. These ribbons of shadows travel around the contour of a limb and help to convey a feeling of graphic solidity.

The junctions of trunk and branch, branch and twig, should be studied, and the thickened unions, the wrinkling and roughening of the bark, and the pockets that often lie within the crotch of a branch juncture, should be expressed. And once the character of branch structure is assimilated, the artist is free to move his branches to satisfy the exigencies of his composition.

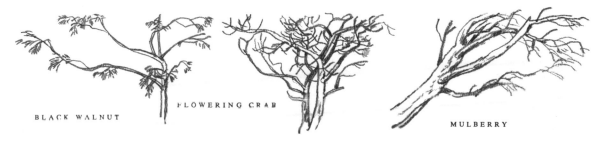

BLACK WALNUT

FLOWERING CRAB

MULBERRY

24

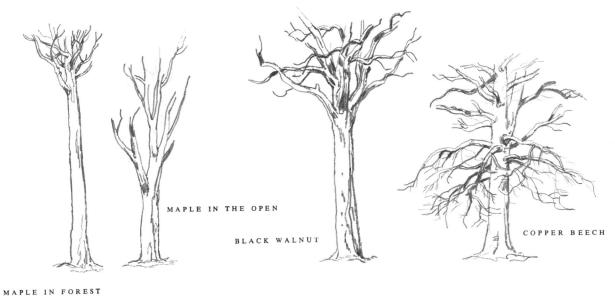

MAPLE IN THE OPEN

BLACK WALNUT

COPPER BEECH

MAPLE IN FOREST

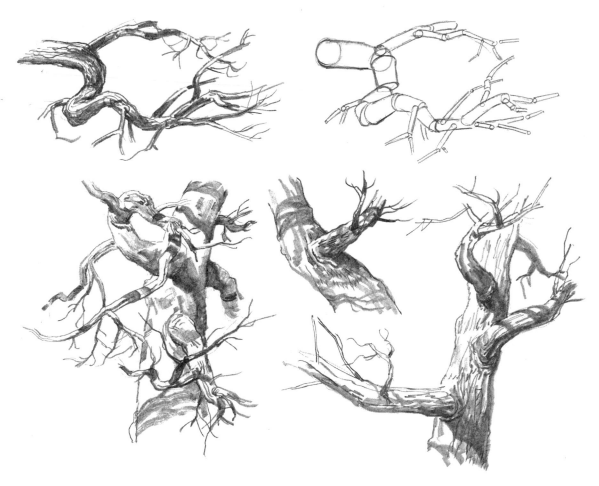

Sketches of Various Bough and Branch Forms

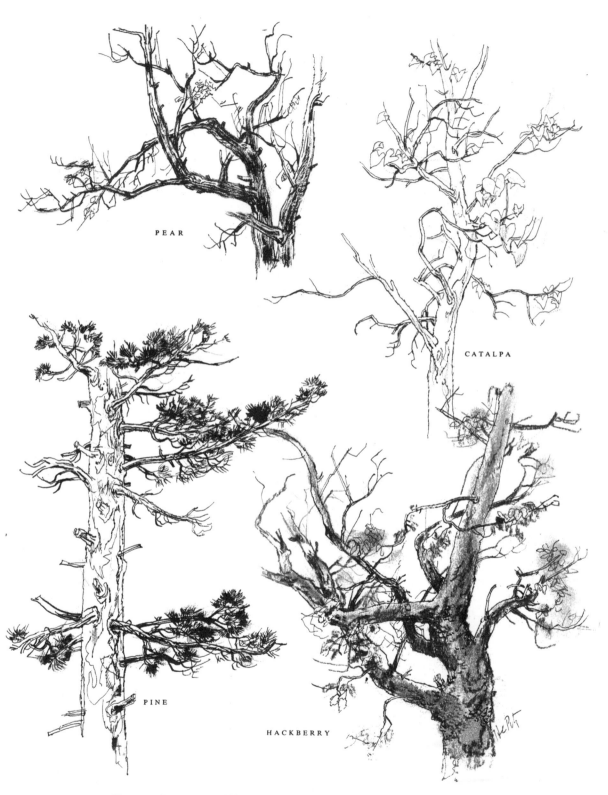

Pear, Catalpa, Pine and Hackberry
Pen and ink with some charcoal on illustration board

26

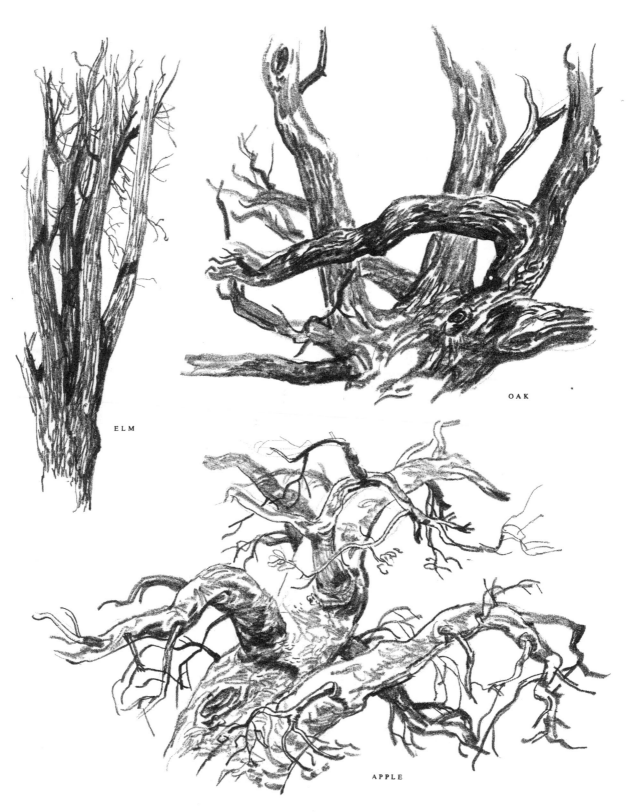

ELM

OAK

APPLE

Elm, Oak and Apple
6B broad-edged pencil on cameo paper

Drawing Techniques

Art students are almost certain to be obsessed by problems of technique. This is natural and right, even when it takes the form of the illusion that there is an ideal technique. There is no ideal technique; all have their advantages and disadvantages. But one may hope to find the technique best adapted to one's own talents and limitations.

One can scarcely expect to find a favorite technique until one has tried many, but a hasty dabbling in one medium after another is almost certain to be confusing and disappointing. A medium does not disclose its character immediately. A reasonable amount of patience and practice is necessary. If the first efforts are disappointing, the medium should not be blamed; all of the media in this book have yielded masterpieces from the right hands.

An excellent idea would be to practise two media simultaneously, particularly if the media are contrasting ones, as, for instance, charcoal, and pen and ink. Charcoal is easily pushed around, readily susceptible to change and correction, and capable of infinite subtleties; pen and ink is positive, clean-cut and resistive to change. The sometimes opposing qualities of these two media should encourage a more all-embracing response from the student. Later he will discover that a new medium is created by combining the two.

The exploring of new media and techniques is an exhilarating experience for the true artist and should be indulged in by the student freely and naturally, unmindful of any comment that technique spells death for the creative impulse. The creative spirit that is killed by technical investigation is a piddling thing that will not be missed.

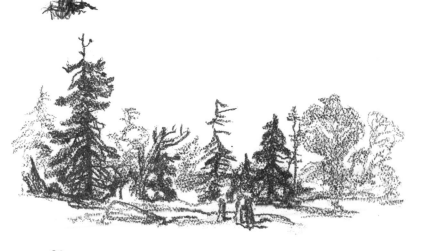

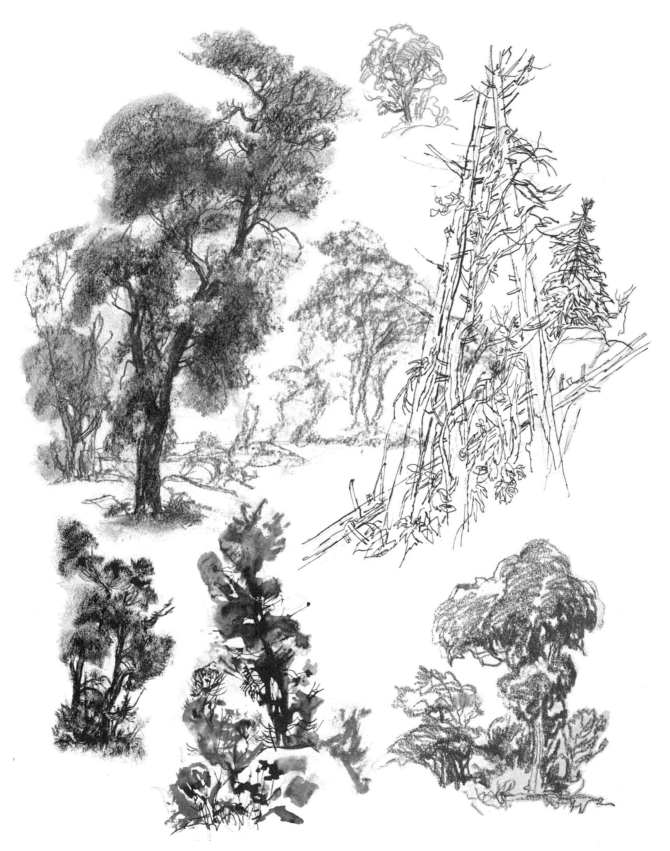

Sketches in charcoal, pen and ink, drybrush, ink wash and pencil

Pencil and Crayon

Graphite pencils come in varying grades of hardness and softness. Most artists find a grade, or grades, agreeable to their purpose ranging from 2H (hard) through HB (medium) to 6B (soft). Obviously the hard grades encourage precise linear drawing, the soft grades lend themselves to a looser technique in both line and tone.

Sooner or later the student should test out many, if not all, of the points available, but there are so many degrees and types obtainable that considerable confusion can result from wide experimentation at the beginning. An excellent start may be made with just two pencils, the ebony jet black (Eberhard Faber) and the wide-edged sketching pencil, 6B (Hardmuth). These two pencils can be used very advantageously in the same drawing, the broad strokes of the sketching pencil can build up a tone rapidly, as in foliage masses, and patches of foreground; the ebony, used with either sharp or blunt point, can define edges and sharpen details. The beginner, who worries about the *direction* of his strokes, should be told that any direction is possible as long as it discloses form and texture. If this seems too general a statement to be useful, and he wishes a comforting formula, let him determine the contour of a surface and then draw his strokes *with* the contour or *across* it, as is demonstrated on the facing page.

Successful pencil rendering depends a great deal on the papers used. There are countless good surfaces, from the numerous bond papers, through the smooth and medium surfaced drawing papers to bristol, chamois and illustration boards and even special surfaces, such as the excellent, chalk-coated Cameo stock. Very rough papers are usually not desirable as they break up line and tone too much. Here again, personal choice becomes important; the artist is obligated to experiment until he finds the surface that suits him best.

Another fine sketching pencil is the Wolff carbon drawing pencil, ranging from hard to soft degrees. It yields a velvety black line, and draws across the paper with a dry, slightly gritty feel in contrast to the more slippery stroke of the graphite pencil. Smudged tones can be produced by rubbing and its line combines well with both watercolor and ink.

Lithographic pencils or sticks are popular too. The line produced is a black and greasy one that combines well with ink but resists watercolor. Used by itself on textured paper, it gives a crumbly effect. It does not rub easily.

There are many, many kinds of crayons, like the black and sanguine **Conte** sticks that have been used by generations of artists; others, like the **General's** charcoal white for drawing white details and highlights on dark tones, are new. Artists have never had such a variety of graphic tools available to them, but **the** secret of pictorial magic still resides in the hands that use them.

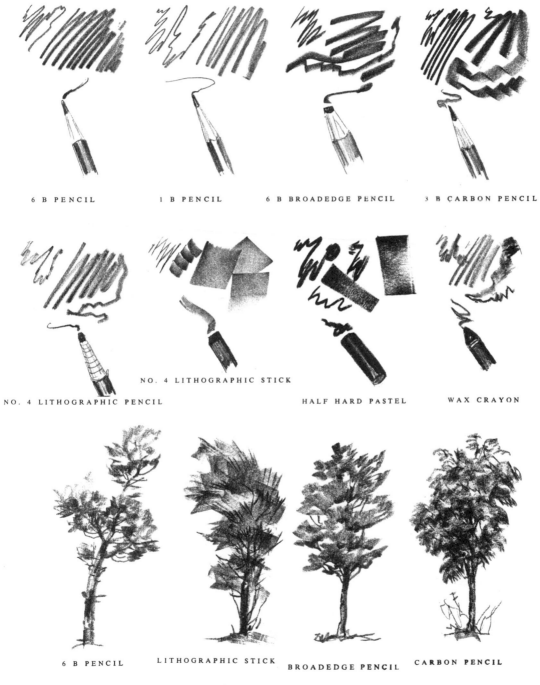

6 B PENCIL 1 B PENCIL 6 B BROADEDGE PENCIL 3 B CARBON PENCIL

NO. 4 LITHOGRAPHIC STICK

NO. 4 LITHOGRAPHIC PENCIL HALF HARD PASTEL WAX CRAYON

6 B PENCIL LITHOGRAPHIC STICK BROADEDGE PENCIL CARBON PENCIL

Demonstration of various pencils on media paper

31

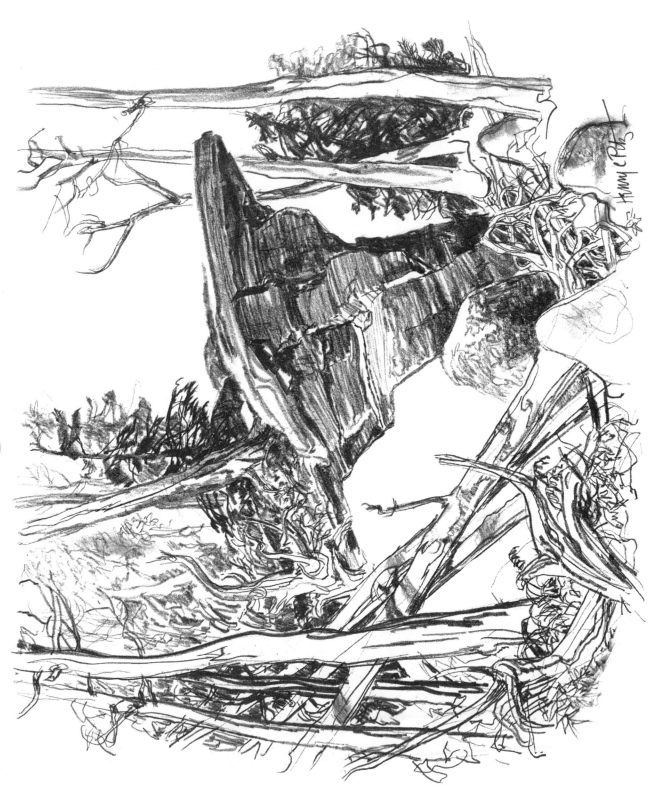

Trees on Rocky Ledge
Carbon pencil on media paper

32

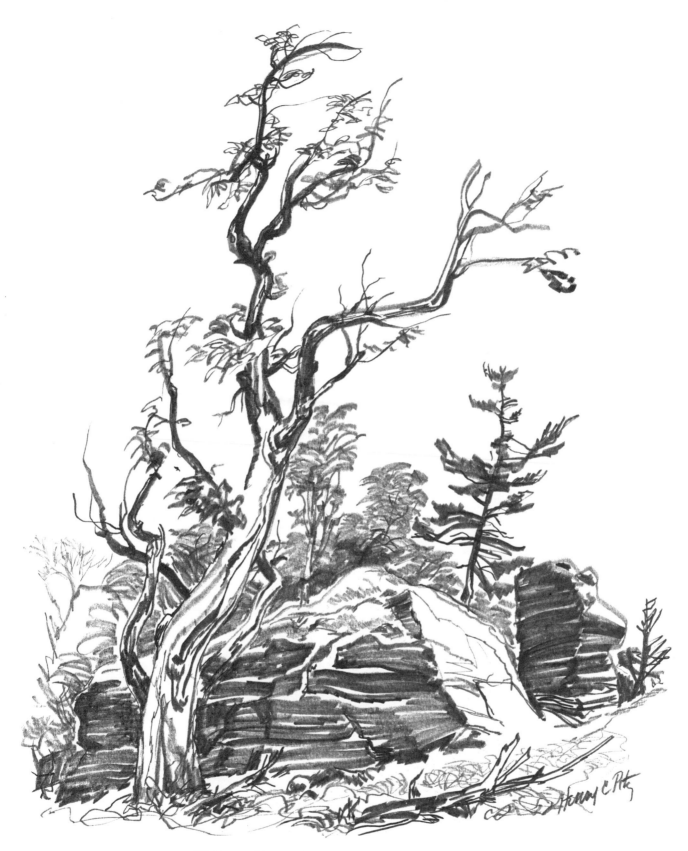

Hilltop Growth
6B broad-edged pencil on cameo paper

Pen and Ink

Pen and ink is a difficult medium, but because of the demands of effort, scrutiny and manual coordination that it makes upon the artist, its rewards are infinite. Because the pen line is a mark that is difficult to change or erase, the medium forces one to observe and plan before drawing. It discourages fumbling; it encourages forthright pictorial statements.

Its materials are few and simple: a pen point and holder, a bottle of ink, and a sheet of paper. There are many sizes and kinds of pen points, and the type selected has considerable bearing on the effect obtained. Ordinary writing pens may be used, but, in the main, they are inclined to be stiff and unresponsive. The points made for drawing by Gillot, Hunt, Esterbrook and Spencerian offer a plenteous variety.

The type called the "crowquill" is a delicate but very flexible instrument—Gillot's 659 and Hunt's 102 are two that may be recommended. Other delicate points are Esterbrook's 62, 63 and 64, and Hunt's 108. All these points make very delicate lines but reasonable pressure will thicken the line considerably. For the beginner, the danger in using these points is that they encourage any tendency toward niggling and fussiness.

Other pens which are less fragile and more suitable for average work are: Gillot's 303, 404, 170, 290, 291; Esterbrook's 356, 357, 358; Hunt's 22; and Spencerian's 98.

For outdoor sketching, fountain pens are convenient. The ordinary types cannot successfully use India ink but there are several makes of drawing fountain pens now on the market that do.

A waterproof India ink is usually used for drawing but sometimes ordinary writing ink is preferred because it can be smudged and modeled with a damp finger after it is dry.

Almost any paper that contains enough size so that the ink line will not blur can be used. A minute's scribbling with the pen will tell if a given kind of paper is suitable. The usual artist papers are made in three surfaces smooth, medium and rough, and, of course, the texture has a great influence on the finished result. Smooth permits a fine copperplate line; medium presents enough resistance to give a slight irregularity and character to the line; and rough gives a broken line.

Bristol boards and illustration boards, because of their thickness, are a convenience in sketching, but their paper, like writing bond or single ply drawing papers, are much cheaper and will work equally well if backed up by a pad of paper or a perfectly smooth drawing board.

If pen and ink is a completely strange medium, some time should be spent making all conceivable varieties of lines and marks (some examples are given below). There is no best method; all kinds of marks and shapes can be utilized in solving the many-sided problems of texture tone and form. The fingers may be used to smudge wet lines of waterproof ink or a moist finger to blend a dry area of non-waterproof ink. Tones are created by grouping lines and marks more or less closely together. Often it is convenient to form tones by a series of parallel lines and darker lines, by crosshatching, or superimposing one series of lines upon another. The set of five pen tones below will give an idea of a simple tonal scale which may be used in pen rendering.

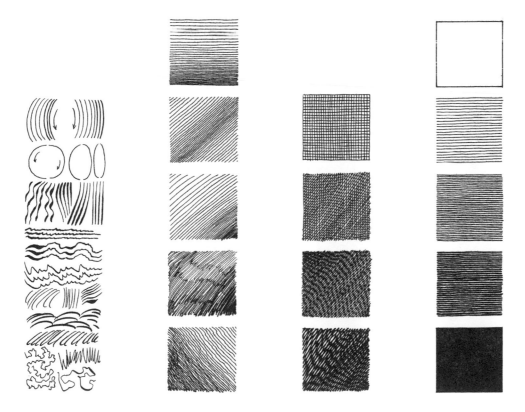

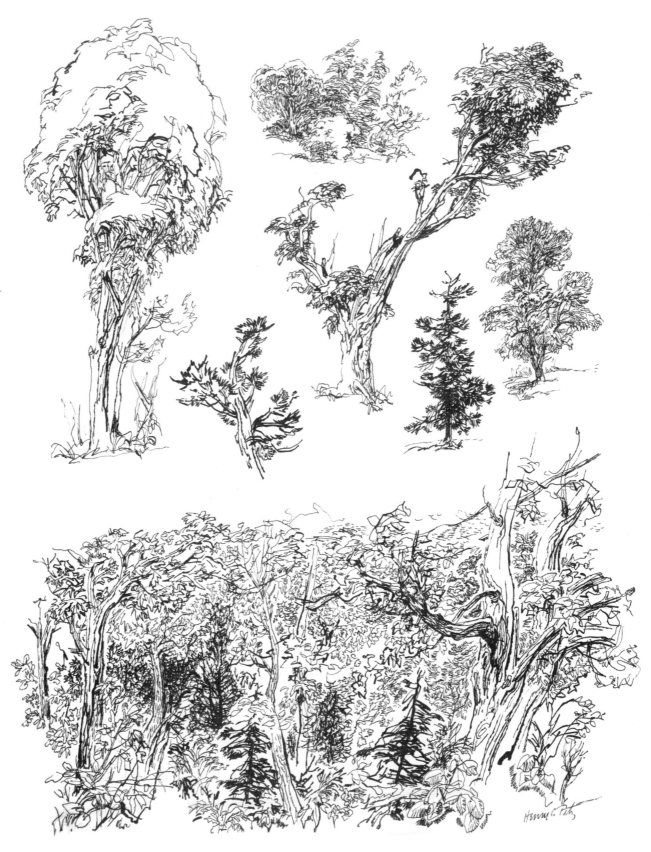

Pen Sketches
Crowquill and 303 Gillot pens on illustration board

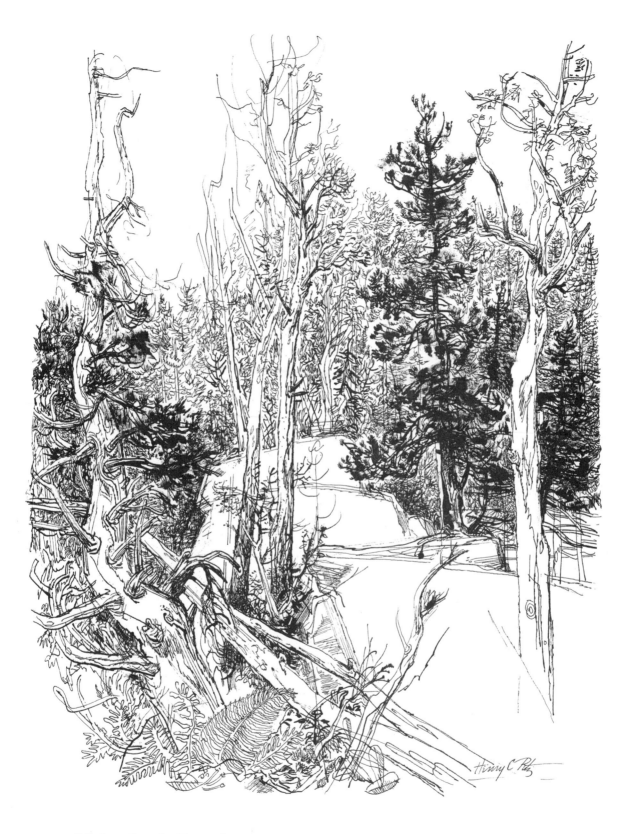

Maine Scrub Growth
Crowquill pen (some areas finger smudged) on illustration board 37

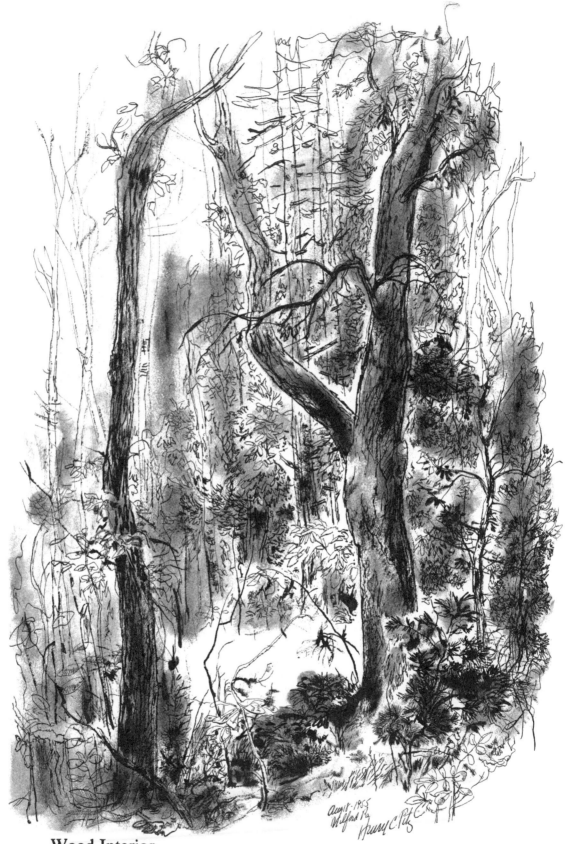

Wood Interior

Ink smudged with moistened finger on Whatman watercolor paper

38

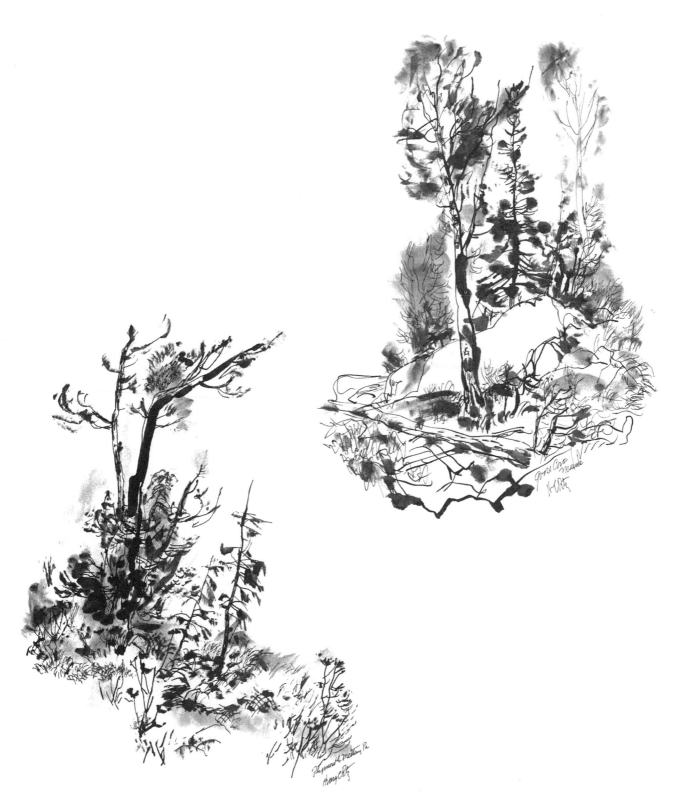

Two Sketches
Ink smudged with moistened finger on bond paper

39

Drybrush and Split-Brush Techniques

The brush is such a fluent and versatile tool (without any of the crankiness of the pen, for instance) that many consider it the best all around sketching instrument. A good quality red sable brush (No. 3, 4 and 5 are the most used sizes) can make a line of astonishing delicacy and will, with a little pressure, expand to a fat, rich ribbon of black.

The brush dipped in ink will also render two interesting effects, the *drybrush* line or tone and the *split-brush* or *multiple* line. The drybrush technique gives lines of interesting irregularity and tones that are built up of tiny and various shaped islands of ink on white paper. The tone can be deepened by repeated strokes until it is a black tone flecked with tiny spots of untouched white paper.

To produce a drybrush tone, most of the ink is wiped from the brush on a blotter or scrap of paper. In wiping, pressure should be applied to the brush so that it spreads out fanwise. The remaining ink will hold it in this position and the brush-fan should be drawn across the paper. A deposit of ink will be left in tiny speckles on the high spots of the paper texture. Of course, a smooth paper is not very satisfactory, some tooth is necessary and variations in the paper's texture plays an important part in the effects obtained. Each time the brush is charged with ink and wiped, it should be tested on the same kind of paper as that on which the study is being made. Too much ink in the brush can easily ruin a carefully built up gray tone. A whole gamut of gray tones are possible in this technique, as can be seen on the facing page and on many other pages in the book. Of course, drybrush tones combine beautifully with pen and brush lines.

The split-brush is also produced by splaying out the wet brush on paper. The fanned out hairs can then be arranged in clumps with a knife blade or needle and each clump becomes a miniature brush in itself. Stroked across the paper, the brush leaves a series of parallel lines at one stroke. The thickness of each clump can also be adjusted so as to vary thick lines with thin ones. This method is excellent for rendering certain textures such as the bark of old trees, and it is a rapid way of building up a crosshatched tone. In both these methods, old brushes that have lost their points are very suitable.

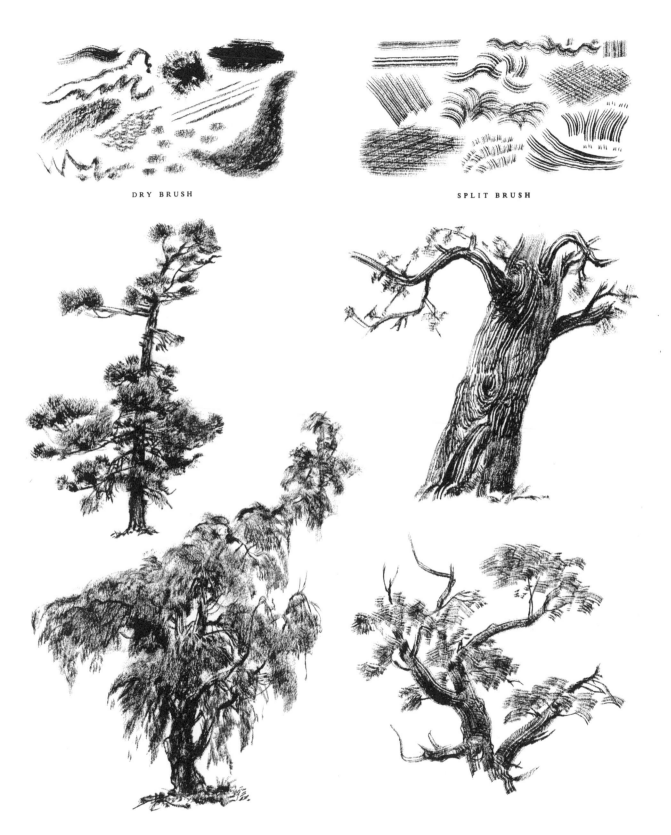

DRY BRUSH

SPLIT BRUSH

Drybrush and split brush techniques on illustration board

41

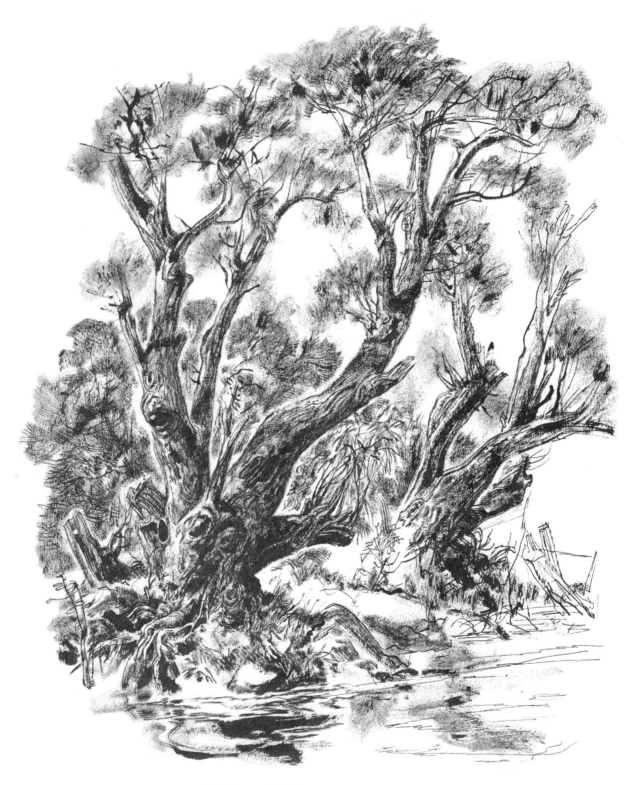

Willows
Drybrush on illustration board

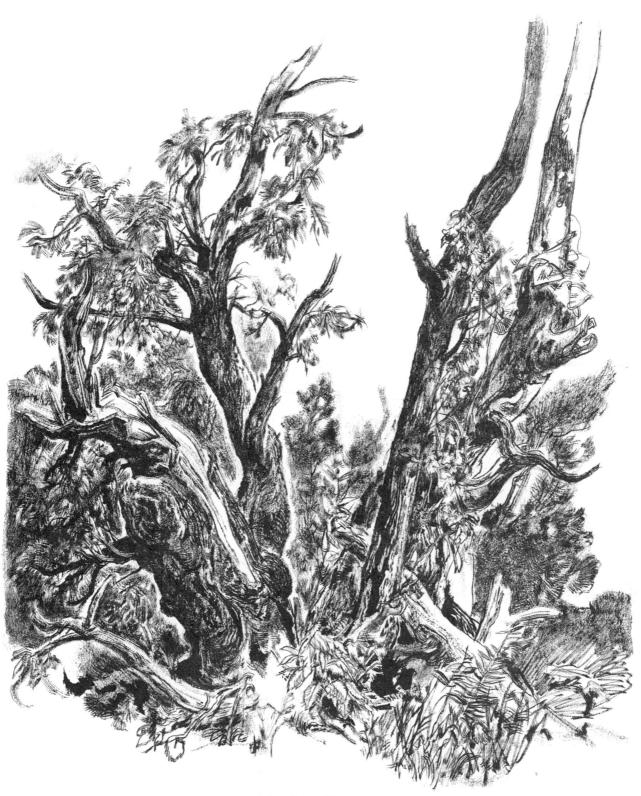

Wind-broken Trees
Drybrush on illustration board

Charcoal

Charcoal is probably the most instantly obedient of all media. Its responsiveness to the slightest touch is both a blessing and a hardship. Its susceptibility to change makes it an excellent vehicle for students who are feeling their way, for it is really at its best when it is handled freshly and straightforwardly.

Charcoal usually comes in stick form, in hard, medium, and soft varieties. There is also a compressed variety which is of value in certain techniques. The hard and medium sticks are used largely as a point or line medium and will be preferred by some, but the soft or vine variety is the best sketching medium.

The soft or vine variety encourages one to work broadly with large areas of tone, supported with crisp strokes from the point. A tone is quickly obtained by dragging a short stick broadside across the paper. This practice gives a light or heavy speckled tone according to the pressure used (this tone is very suitable for certain foliage effects). If a smooth tone is desired, this is easily obtained by rubbing lightly with a finger. A still smoother tone is obtained by rubbing with a paper stump (a pencil-shaped roll of soft paper). The finer point of the stump is excellent for modeling details that are too small for the finger.

The compressed charcoal comes in heavy sticks, too thick for anything but the boldest line drawing, but it produces a velvety black tone that cannot be rivaled by the other kinds. Compressed charcoal should be used freely and directly; too much manipulation will create a greasy surface which will have a tendency to repel further drawing. It is excellent for touching up the darks in an otherwise completed drawing in soft charcoal. Large sections of tone are easily reduced in value with a clean, dry finger, but a kneaded eraser is necessary to pick out highlights and to model detail.

In all charcoal drawing, the paper surface is of prime importance. A certain amount of texture is usually desirable depending upon the effect sought for; highly sized and glossy papers are considered too slippery by most. Paper makers have prepared a wide selection of papers especially for charcoal; most illustration boards and watercolor papers are suitable as well as some kinds of manila paper, tracing paper and even some wrapping papers.

Charcoal drawings should be protected by spraying with fixative, using either the cheaper spray pipe or the more pleasant spray gun.

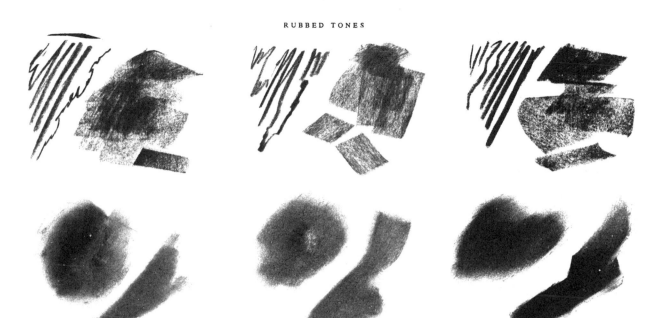

SOFT (VINE) CHARCOAL HARD CHARCOAL COMPRESSED CHARCOAL

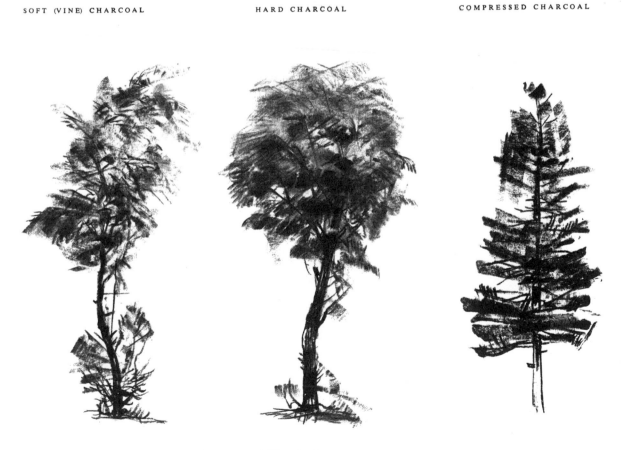

Charcoal Techniques
Various charcoals on media paper

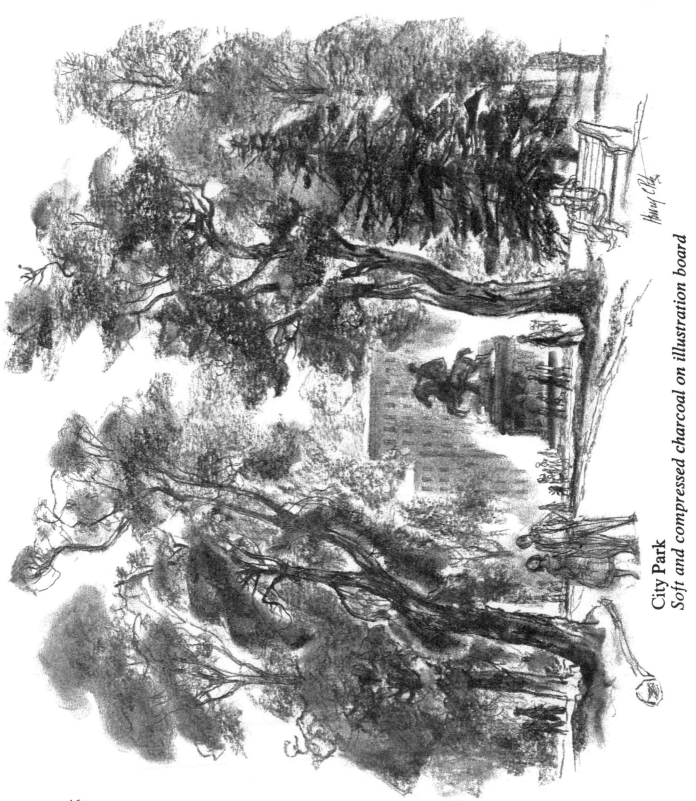

City Park
Soft and compressed charcoal on illustration board

46

Landscape
Soft charcoal on cameo paper

The Fountain Brush

The fountain brush is a rather recent invention that has found favor rapidly, for it is at least one answer to the cry for simplicity of sketching equipment. A sheet of paper and a fountain brush and one is ready for the road.

The fountain brush has a reservoir filled by means of a dropper with a special penetrating ink. The nibs are made of felt in a number of shapes so that strokes may be made, ranging from a fairly fine line to a ribbon of perhaps a quarter-inch width. The nibs can be changed in a matter of seconds, or several brushes may be carried, each with a different nib. Incidentally, although filling the reservoir with a dropper or by pouring from the bottle is a nuisance, it is possible to make a great many sketches between refills.

In most types of fountain brush, there is a valve which allows the ink to flow when the nib is pressed against the paper. In some, the valve is so adjusted as to give a gray mark with light pressure and a dark mark under heavy pressure. But the fountain brush is not exactly a sensitive tool. It is at its best when handled in a bold, sweeping way, with a positive tonal statement as an aim, and not much stress laid upon subtleties of line or tone. It is not a good tool for small scale sketching or the handling of minute detail; it requires elbow room.

The ink it uses has great penetrating power, so that it sometimes soaks through a sketch on thin paper to the surface beneath. Also, because of this penetrating property, it does not work well on paper that is unsized or lightly sized; it spreads blotterwise. On the other hand, provided sufficient sizing is present, it will work on a wide variety of surfaces. The inks come in a variety of colors, so that, using a pen for each color, one can paint a full color picture.

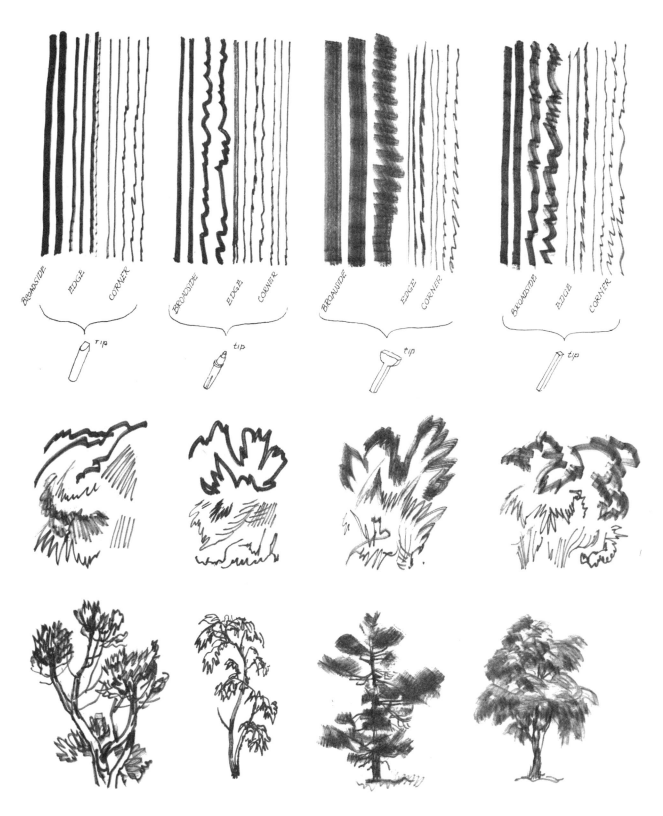

Fountain brush technique on bond paper

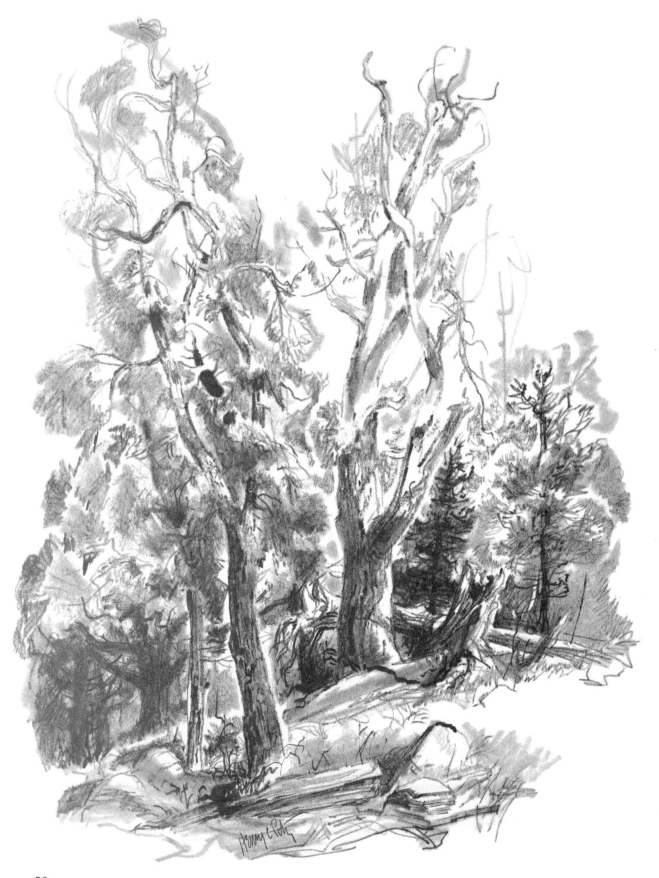

50

Woodland Edge
Fountain brush on illustration board

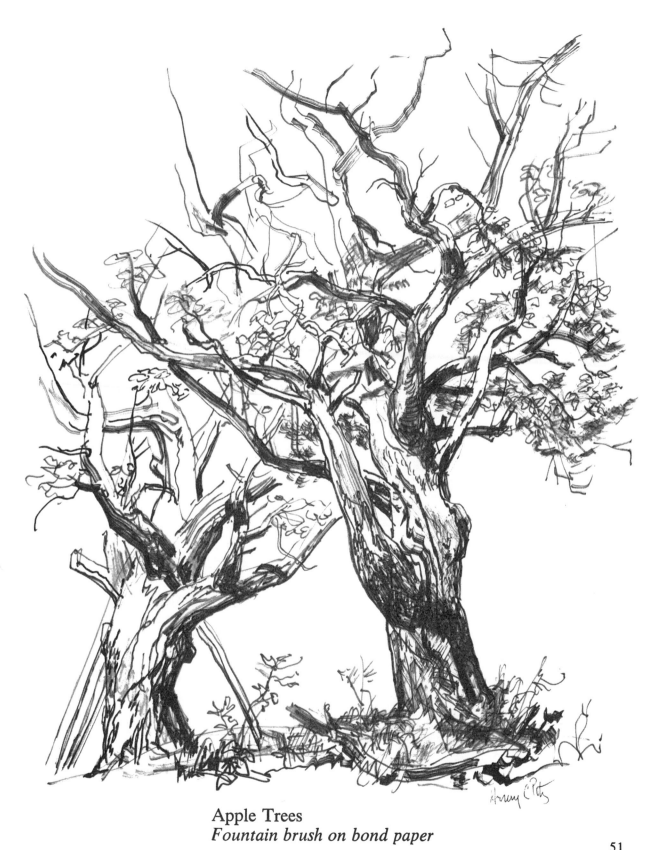

Apple Trees
Fountain brush on bond paper

The Mixed Media

A whole new series of effects can be obtained by mixing two or more media. Some mixtures are natural and productive, others are unnatural oddities. One of the earliest combinations discovered by artists was that of the ink line with washes of watercolor. If the basic drawing of a picture is done with waterproof India ink, washes of tone or color may be freely applied, once the ink is dry, without fear of the drawing running or being obliterated. This method has the advantage of enabling the artist to tackle his problems piecemeal; first, he may search out his composition and forms with pencil and eraser; then define the forms and indicate texture with the inked brush or pen; finally, this skeleton drawing may acquire volume and tonal depth by brushing on the washes of watercolor.

For monochrome drawings, ivory black or sepia are the watercolors usually used, but the ink itself may be diluted with water and brushed on. Ink washes have a tendency to dry immediately with hard edges so they do not have the same fluency as watercolor, particularly when large areas have to be covered. Very interesting effects, however, can be created by drawing with inky pen or brush into an area of water-soaked paper, as can be seen in the examples on the other page. Experiments should be made on odd scraps of paper until the proper amounts of water and ink are discovered.

Another natural partner for the ink line is charcoal. Over the ink drawing, charcoal (soft preferably) may be scumbled, or rubbed in. This is an excellent method for the experimenting student since the charcoal tones may be easily removed or changed. Another medium that blends well with the ink line is the lithographic crayon, particularly when used on a paper with some tooth.

Graphite pencil, wash, and ink are old associates, in any combination of two or all three together. But graphite pencil and charcoal together are not very satisfactory, the grease of the graphite resists union with the dry charcoal. Carbon pencil makes a better blend with charcoal, as do the conte crayons.

One of the oldest of artists' tools is a moistened finger smudged with pencil, crayon, ink, or just dirt. This can create some delicate nuances of tone, but because, perhaps, it is considered slightly unsavory, it is never mentioned in the textbooks.

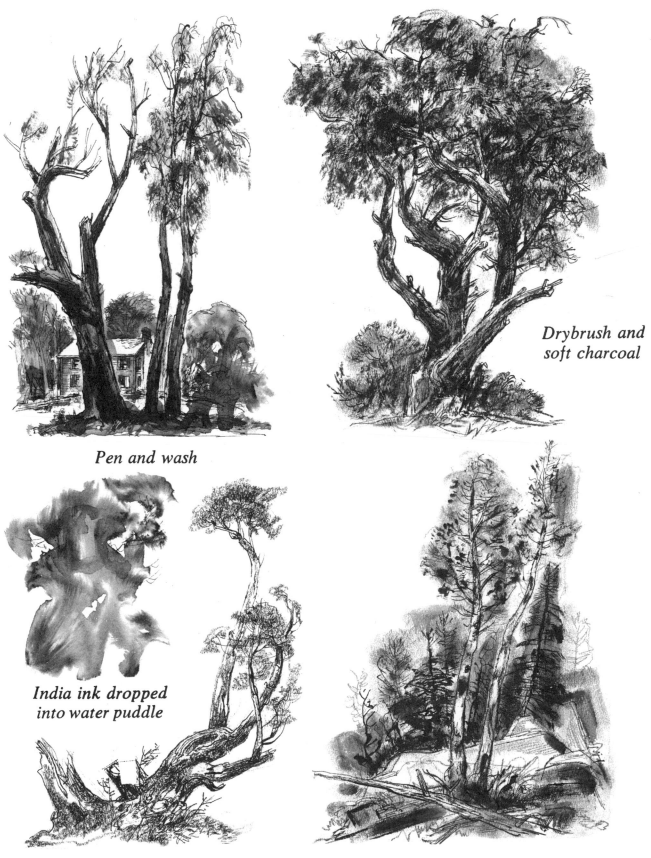

Pen and wash

Drybrush and soft charcoal

India ink dropped into water puddle

Pen and lithographic pencil

Ink rubbed with moistened finger 53

Various Mixed Techniques

Pennsylvania Village
Pen, drybrush, ink wash and soft charcoal on illustration board

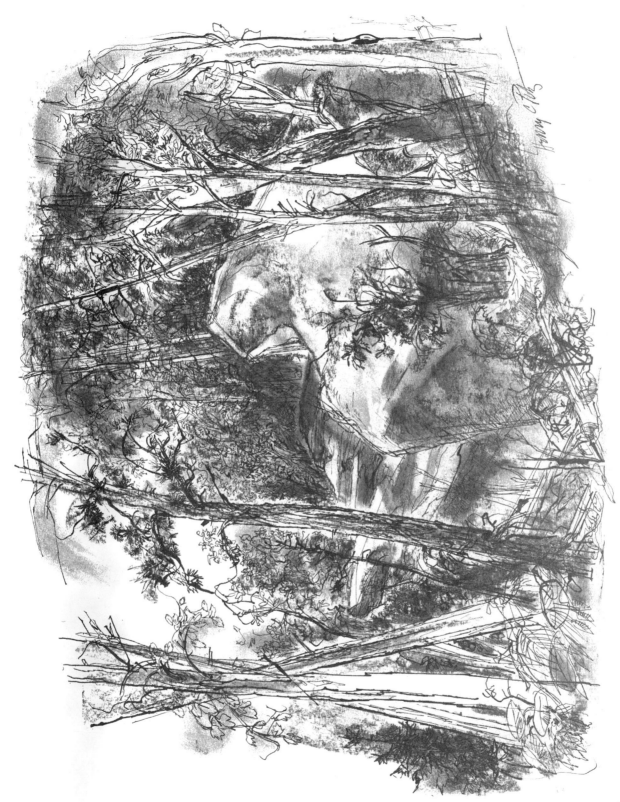

Maine Woodland
Pen, drybrush and soft charcoal on illustration board

55

Some Familiar Trees

The artist, quite naturally, with his innate appreciation of unusual forms, colors and textures, gravitates toward those trees which have marked individual characteristics. If he wishes, he may search out the most exotic trees that our planet has produced and make fantastic designs of them, but if he is interested at all in making a pictorial comment on the land around him, he is confronted with the ever-recurring forms of familiar trees.

Fortunately for him, any sizable group of familiar trees shows considerable diversity. On the opposite page are the silhouettes of eight common trees: Weeping Willow, White Oak, Paper Birch, Elm, White Pine, Balsam Fir, Sycamore, and Red Maple. These are trees likely to be encountered in a majority of American landscapes and yet they offer wide differences of shape, color, foliage, and bark textures.

It goes without saying that this is not the only group that could be selected for beginners' study, but any student who will search out, identify, and draw repeatedly these eight trees, or a comparable group, will soon be possessed of a working vocabulary in the language of landscape drawing and painting. How deeply the student will venture into the botanical lore of trees will depend upon his own interest and inclinations, but the repeated drawing of tree forms piles up its own store of visual impressions in the memory, and from the growing richness of such a store will come the fluency and familiarity upon which landscape artists depend quite as much as upon immediate observation.

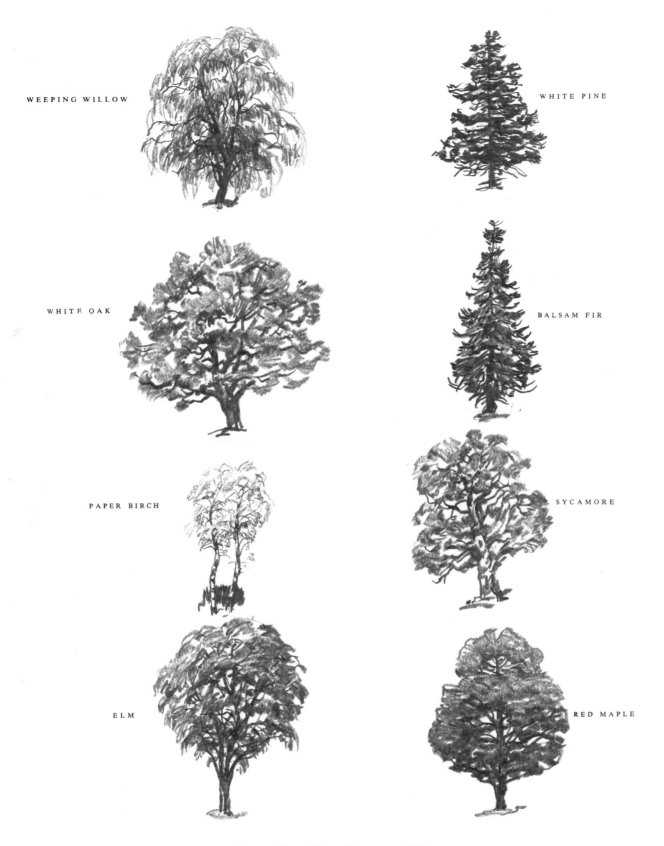

WEEPING WILLOW

WHITE PINE

WHITE OAK

BALSAM FIR

PAPER BIRCH

SYCAMORE

ELM

RED MAPLE

Some Familiar Trees — Silhouettes
6B pencil on cameo paper

57

The Oaks

The Oaks are the largest and one of the most interesting of the tree families. All the Oaks have positive personalities but a study of the entire family is a project in itself. For purposes of simplicity, two varieties may be selected as differing considerably from each other and typifying the region where they flourish.

The White Oak is the northern Oak, a monarch of a tree when growing under favorable conditions. In the open field one is impressed by its sturdy engineering and its eternal look. Its short heavy trunk supports with ease, massive horizontal limbs. It carries a rich cloak of foliage but not enough to hide completely the mighty articulation of its skeleton.

An Oak wood is a memorable thing. Here the tree grows to a great height in clean lines and high-lifted crown. It does not create a dense and shut-in woodland but sunlight filters in and makes the forest floor luminous.

The White Oak has a light gray bark, the lightest of the Oak barks, and, of course, the inevitable acorns. The acorn is the best means of identifying the Oaks, for, although each variety shows slight differences in its acorns, no other tree produces them.

The Live Oak is the picture tree of the South. It is massive like its northern cousin, the White Oak, but its even heavier trunk supports horizontal limbs that are thicker than the trunks of most trees. These horizontal limbs reach out for amazing distances. A Live Oak may grow no higher than fifty feet, but it is not unusual for its reach to be three times that distance. Left to itself it insists upon being a horizontal tree.

To those accustomed to the deep indentations of the usual Oak leaf, the sight of the Live Oak's leaves will come as a shock. They are small and elliptical, with smooth edges, glossy green on top and whitish on the under side. Moreover, they are evergreen. As in the case of the Bald Cypress, we can usually associate Spanish Moss with the Live Oak.

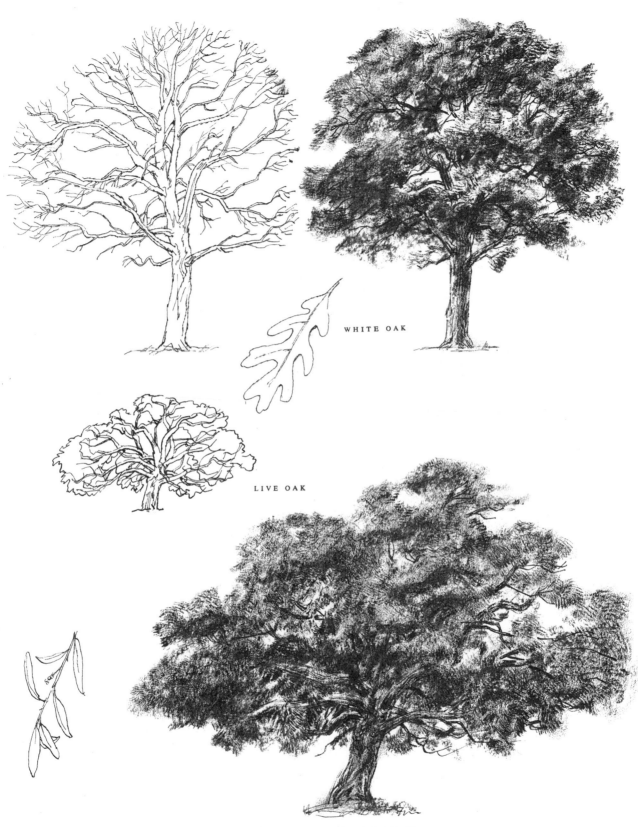

WHITE OAK

LIVE OAK

White and Live Oaks — Skeleton and with Foliage 59
*Pen outline; also drybrush with **soft charcoal on illustration board***

Live Oaks
Drybrush and soft charcoal on illustration board

60

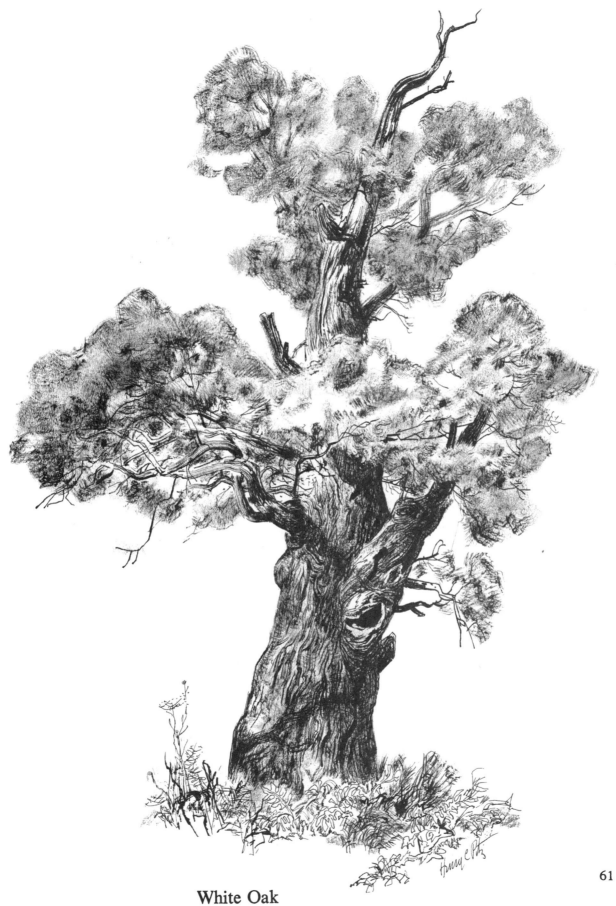

61

White Oak
Drybrush on illustration board

The Elm

The American Elm is one of our most beautiful trees. When free to develop its best characteristics, it rises from a straight graceful trunk, its branches arching gradually outward as the tree fans out in a great fountain of green. It is a magnificent tree growing alone in a New England meadow, and equally beautiful lining the two sides of a village street, meeting overhead in a high arch of foliage.

The Elm is widespread in many parts of the country, and since it is loved by almost everyone, and since it is not particularly valuable for its wood, it survives where other trees disappear. It is found mixed with all kinds of other trees in the woods, and field borders, and yet because of its beauty, is often permitted to grow as a specimen in field or meadow.

In drawing a tree with such a definite character, it is wisest to indicate lightly the principal branch structure before clothing it with foliage. At the top and edges of the tree silhouette, notice how the arching and spreading branches begin to sag and gradually drop downwards. The leaf is rather small and the foliage mass is not too dense, so the technique should aim at a feeling of grace and airiness. The bark is moderately corrugated, so this texture can be of great pictorial interest in close-ups of the trunk. Branches on a fully grown tree are not usually found close to the ground, but the main branches begin to spread at a point about one-quarter or one-third of the height of the tree.

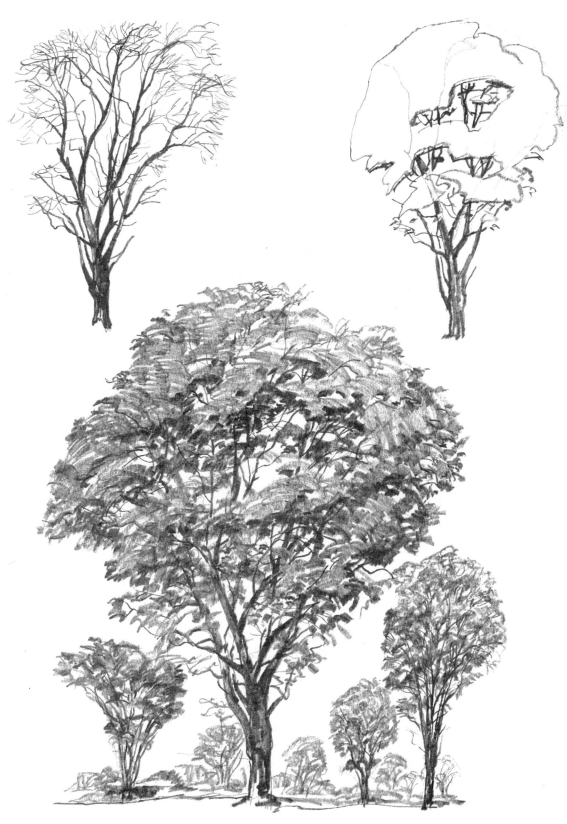

The Elm
6B pencil on cameo paper

63

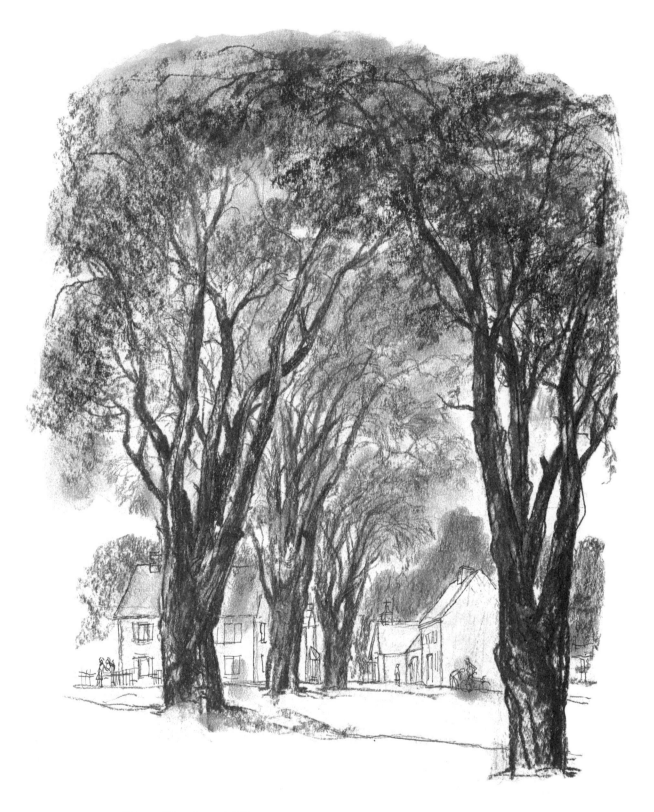

New England Elms
Soft charcoal with some pen lines on illustration board

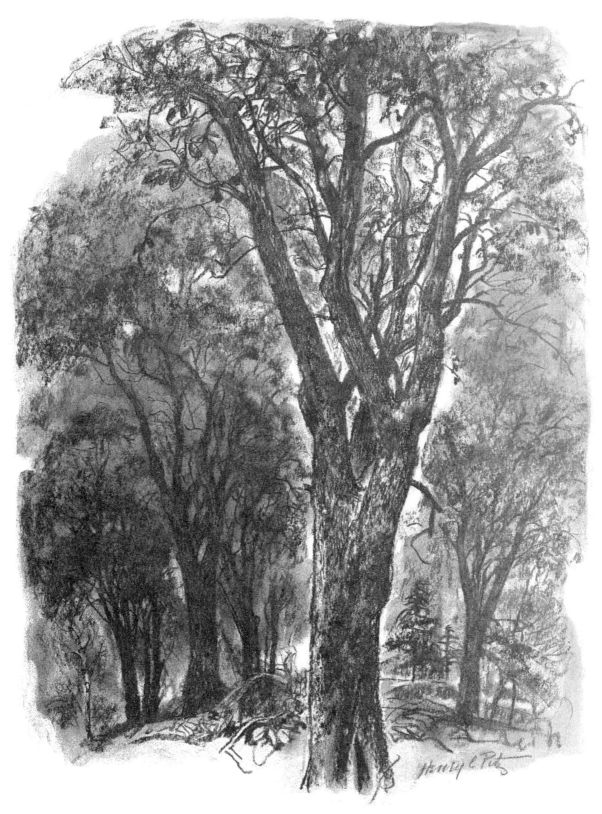

Elms in a Grove
Soft charcoal on illustration board

The Birch

The Birch is one of the natural picture trees. Like the Weeping Willow, it has acquired a bad name in certain quarters because it has been a much recurring motif in so many sentimental postcards, calendars and paintings. But for the landscape artist, confronted with so much sameness of form and color, its light glistening trunk gives him a welcome note of contrasting color and tone.

There are three widespread varieties: Paper Birch, Gray Birch and Yellow Birch. The Paper Birch is the only variety that most people know, and most are unaware that there are any differences between the Paper and Gray varieties. The Paper Birch, of course, is so named because its thin white bark may be peeled off in wide horizontal sheets like a roll of paper. These peels of outer bark reveal the delicate orange inner bark and so give the trunk and older branches their familiar banded appearance. It is a northern tree, common on the hillsides and lakeshores of New England and Canada, growing often in clumps, edging into the clearings at the woodland fringe and springing up in cutover or burned-over land.

The Gray Birch is a more weed-like tree, springing up on scanty soil as far south as the Potomac. Its bark is a gray white and does not peel in horizontal layers, but is marked with irregular dark patches, particularly the black triangles where old branches have broken off.

The Yellow Birch is a much less conspicuous tree. It likes the shadow of the woodland and its dull golden bark gathers in irregular curls and clumps. One characteristic of the Yellow Birch when growing on rocky soil is the visible system of long serpent-like roots.

It is only natural when drawing the Paper and Gray Birches to emphasize the whiteness of their trunks by silhouetting them against a dark background of hardwood or evergreen foliage. After all, this is what usually happens in nature. But a Paper Birch against a luminous sky is also a beautiful thing.

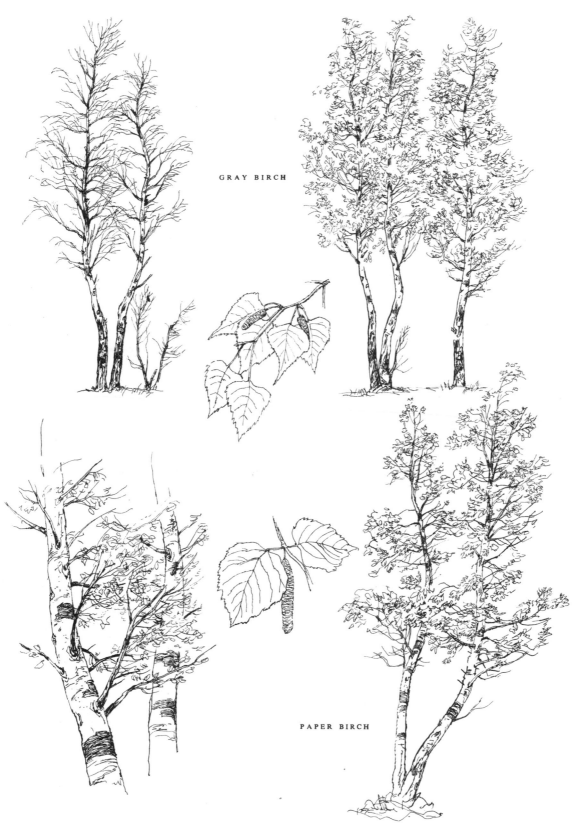

GRAY BIRCH

PAPER BIRCH

Gray and Paper Birch
Pen and ink on illustration board

67

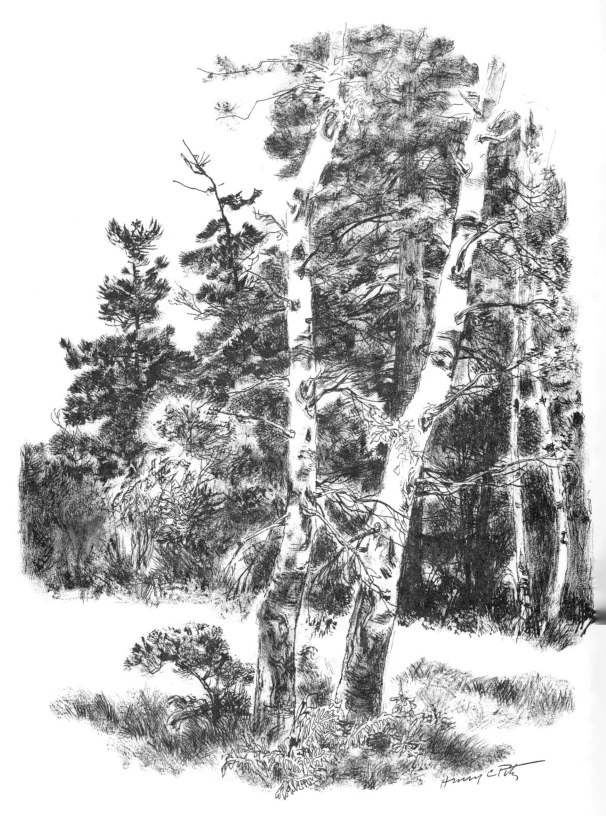

Paper and Gray Birch on the Woodland Fringe

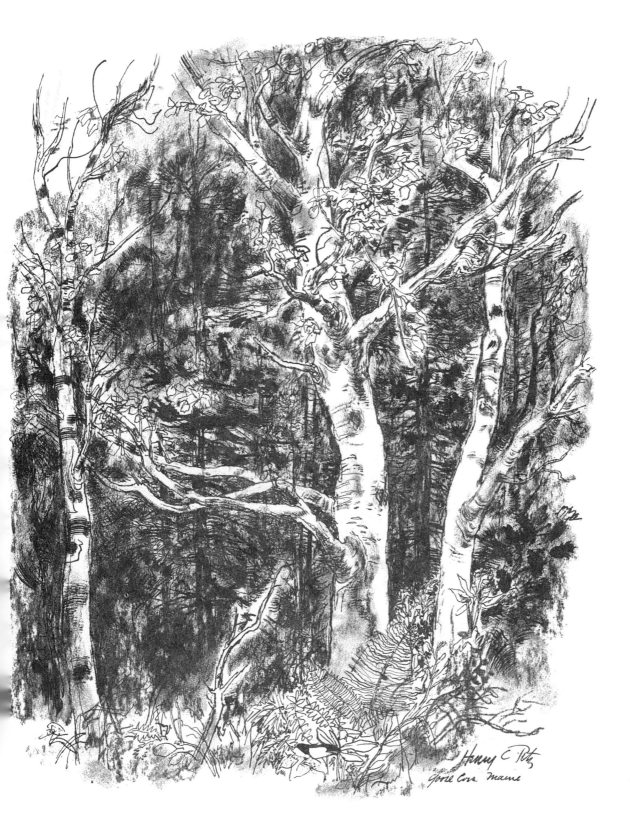

Pen, drybrush and soft charcoal on illustration board

The Evergreens

The Evergreens have always appealed to artists for a number of reasons: they offer a series of shapes that differ from most of the deciduous trees; their dark needles form a contrast to the lighter greens of deciduous foliage; and their shape and color remain constant against the shifting background of the seasons.

The Pine family, which includes the Spruces, Firs, Larches, Cedars, Hemlocks, and Bald Cypress, may be found in almost all parts of the country.

The White Pine is the noblest and best known of the pines. It grows into a giant tree under favorable conditions, with a rugged northern look. Its heavy limbs sweep out at right angles holding angular masses of dark needles. Toward the branches' ends, the twigs grow upward so the needle mass tends to be flattened horizontally below and prickly-edged above.

The Hemlock is another noble, shapely tree, what many would call "Christmas tree shaped." Its short, stiff needles differ from the bunched, more feathery ones of the White Pine. Since it can endure warm weather better than most Evergreens, it is often found mingled with hardwood growth of Oak, Maple, Elm, Hickory, and Beech. It loves moisture and shade; a dark ravine-lined Hemlock grove is one of the sights in the American woodland.

The Spruce and Fir are often found growing together, and in general appearances are very similar. The Red, White, and Black Spruces are arrow-shaped trees, with compact masses of short stiff needles. The White Spruce is usually the handsomest; it is the tall, symmetrical lumber tree of the North woods. The Black Spruce is the rugged, ragged, straggle-shaped tree of the family. Its usually irregular shape reflects its fight with the cold and scanty soil of the northern bogs which is its habitat. The Red Spruce is the most widespread of the Spruce family, with a dark brownish red bark, which, when struck by sunlight, gives the painter the kind of rich color note he delights in. All the native spruces have stiff jutting branches built to carry heavy islands of snow.

The Balsam Fir is known by its aromatic smell to thousands who have never trodden the northern woods. It is the most popular of our Christmas trees. At its most typical, it is a dagger shaped tree with a tip of characteristically up-curving branchlets. Like the Spruce, its needles are short and stiff, but its cones grow erect instead of hanging or turning down as on other Evergreens.

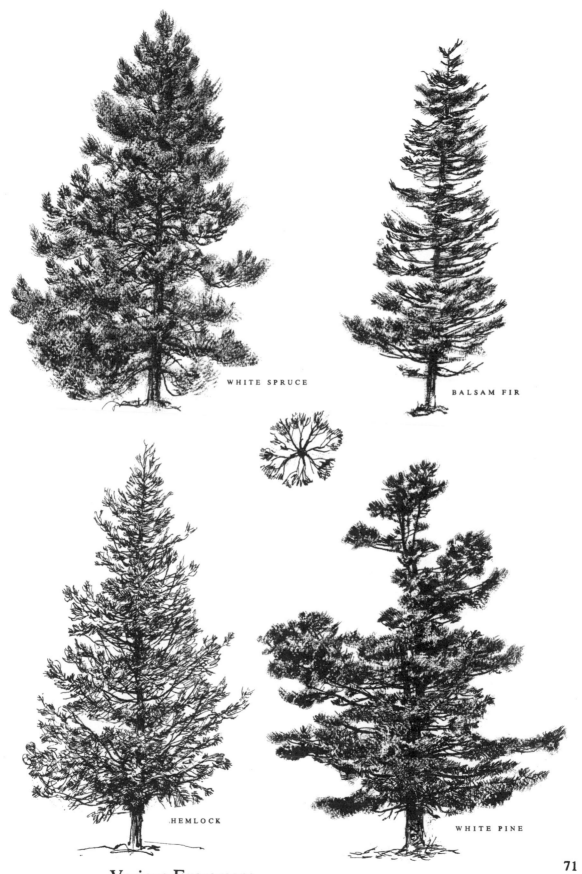

WHITE SPRUCE

BALSAM FIR

HEMLOCK

WHITE PINE

Various Evergreens
Pen and drybrush on Whatman watercolor paper

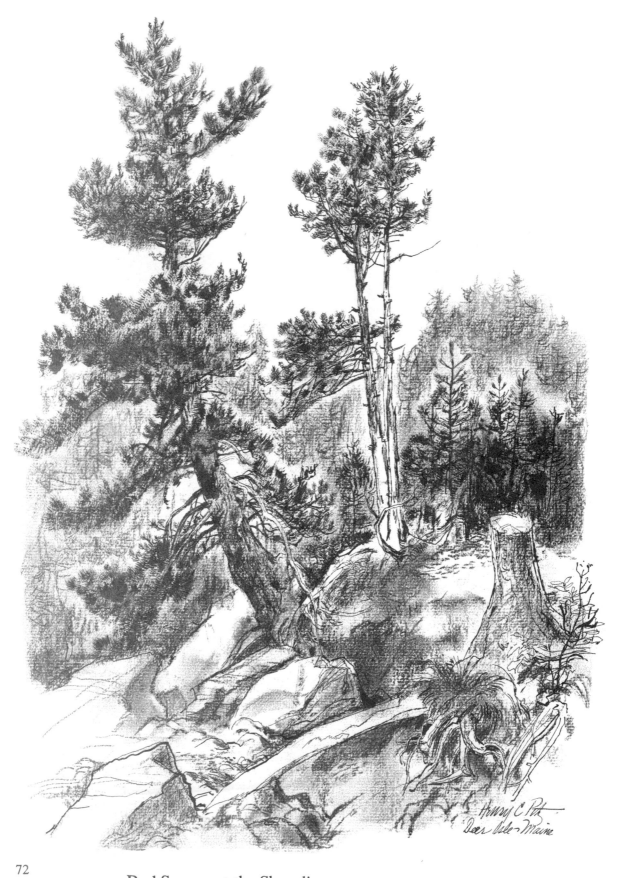

72

Red Spruce at the Shoreline
Drybrush, pen and soft charcoal on umbria paper

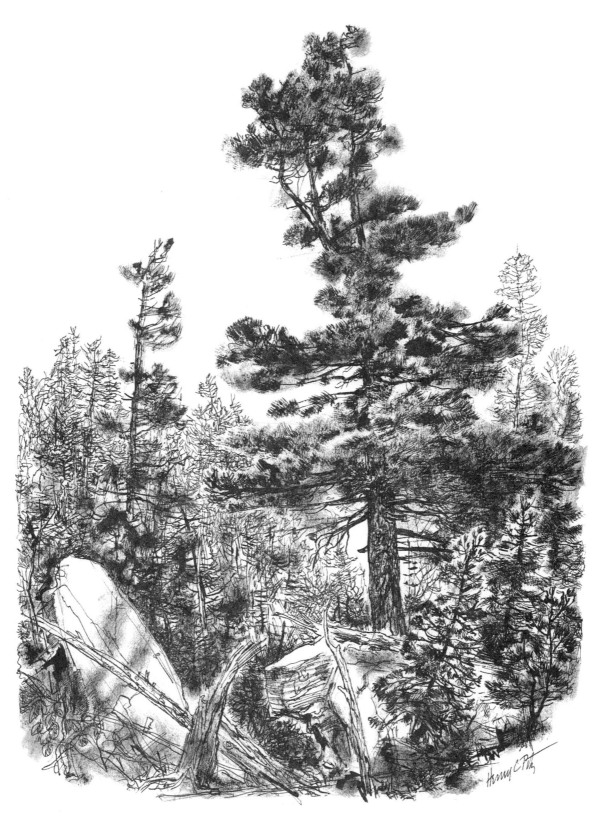

White Pine in Landscape
Drybrush on illustration board

The Willow

The Willow is another of those trees prized by the artist because of its differences. The commonest type, the native Black Willow, is a wide-growing tree of ragged shape. Its trunk is heavy and its principal branches are likewise heavy and often spring from the trunk at sharp angles. Twigs jut out haphazardly from knobs and knots. In spite of its heavy, gnarled and knotted trunk, its crown is light and delicate. Its leaves are long, narrow spears, light gray-green in color.

It is a moisture-loving tree, one of those most likely to be found lining the banks of streams and ponds. It is also one of the most brittle of trees and as it passes the middle of its brief life it is almost certain to be maimed and scarred with the jagged stumps of broken branches. It is one of the first trees to show a haze of tender leafage in the early spring and it clings to its leaves until the last of autumn.

The Weeping variety is familiar to everyone. It has the same characteristics as the Black Willow, except that its long limber twigs hang down often to the ground and drape the tree in a light curtain of greenery.

The Willow is a tree whose erratic shape gives the artist great opportunities to use it inventively, changing its contours to help the design needs of his picture. Its light green foliage can be used as an advantageous contrast to the routine greens of most trees and its twisted and knobby bark is a delight to the seeker for texture and odd rhythms.

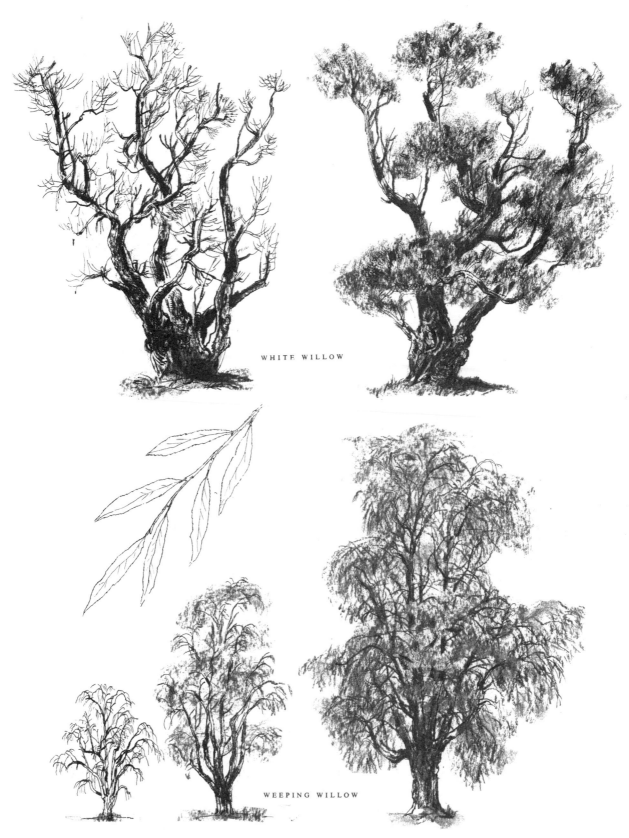

WHITE WILLOW

WEEPING WILLOW

Willows — with and without Foliage
Pen and ink and soft charcoal on illustration board

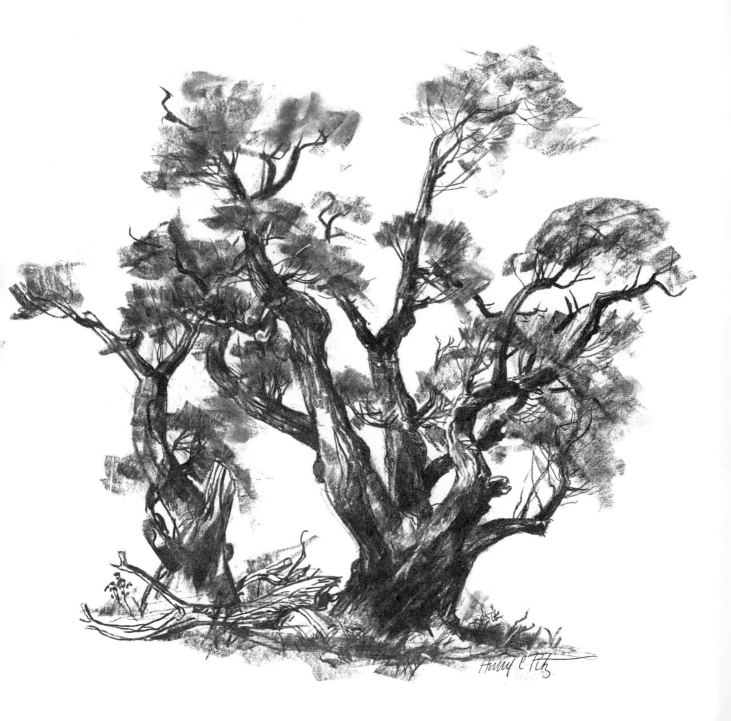

White Willows
Soft charcoal on media paper

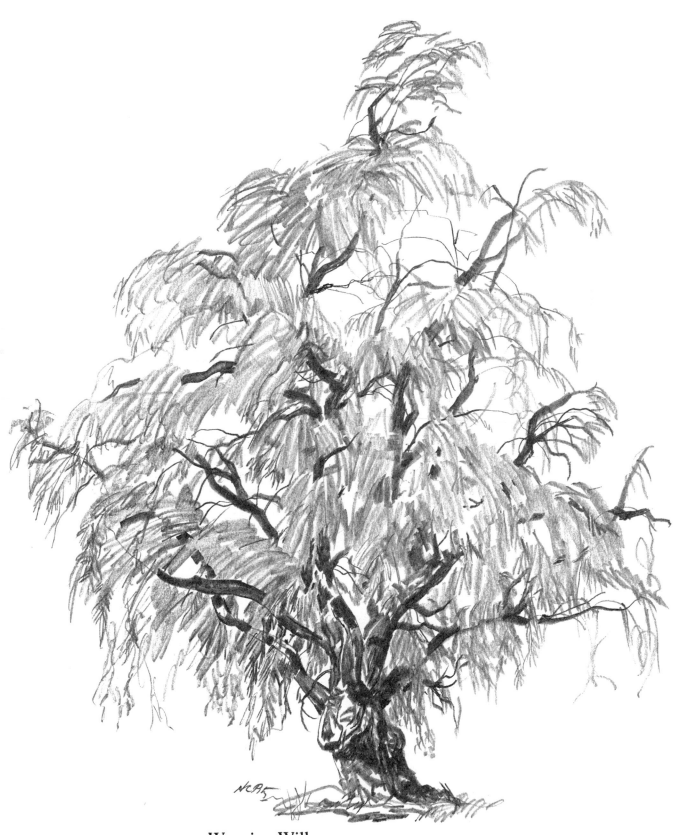

Weeping Willow
6B broad-edged pencil on cameo paper

77

The Maples

The Maples are a large family, but the most handsome of them is the Sugar Maple. All Maples tend to be symmetrical and well-proportioned and the Sugar Maple is usually a fine example of these qualities. In silhouette, it is approximately an oval with a short trunk and rounded crown. In woodland, like all crowded trees seeking the light, its trunk is long and the foliage crown much diminished. Its autumnal foliage is one of most brilliant hues, deep yellows, oranges, and flaming reds. When these brilliant leaves begin to fall, they drop from the topmost branches first, leaving the upper branches bare while foliage still clothes the lower branches. This, of course, is a stage that the artist seizes upon for its pictorial possibilities.

Maples are widespread from Canada to Texas, including the Red, Silver, and Norway varieties. The Red Maple is like the Sugar variety in many ways but smaller, and it likes stream banks, swamps, and generally well-watered soil. Its bark is light gray and often as smooth as a Beech. The Silver Maple has much lighter foliage; the under sides of its leaves are a light silvery green. It sends out long curving branches from a thick trunk, and its branch system is somewhat like the Elm. Since its wood is brittle, it suffers from wind and weather as it grows older, so mature trees are often irregular in form. The less predictable shape of the Silver Maple is frequently a pictorial asset. The Norway Maple has a compact shape and a dense mass of foliage which casts a deep shadow and often prevents grass from growing at its base. The foliage is dark green.

Since the Maples carry dense foliage (the Silver Maple less so), the artist should search for the large masses and block them in. There are usually enough openings to trace the branch system but that system is not nearly as visible as, for instance, in the Sycamore or the Locust. The Maples, because of their mass, are often fine background for the tracery of lighter and more slender trees.

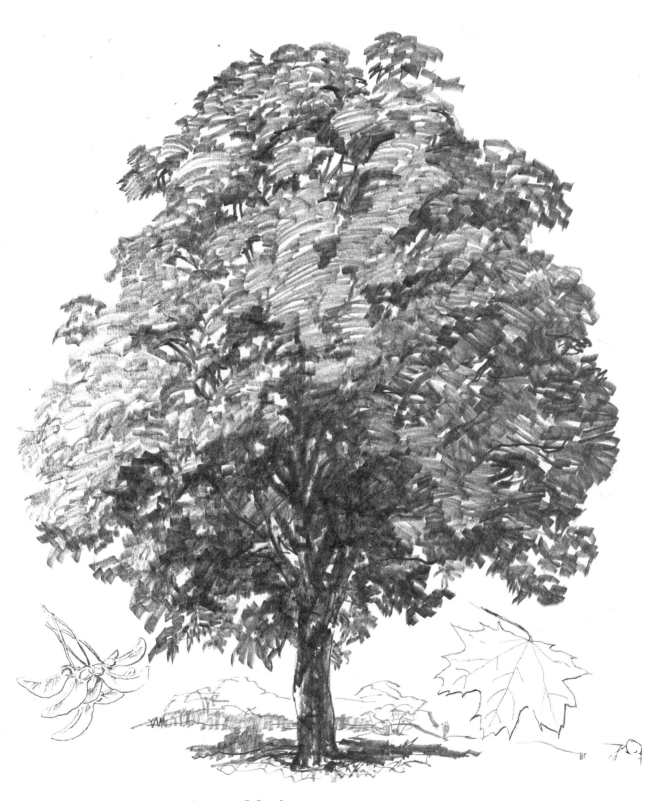

Norway Maple
6B broad-edged pencil on cameo paper

The Sycamore

The Sycamore (sometimes called Buttonwood or Plane-tree) is another of those trees which the artist seizes upon because its bark gives him a refreshing difference of contrast and pattern. Its trunk is usually a patchwork of lemon white, dark ochre, and gray bark. Often its upper trunk and part of its limbs are glistening and smoothly white, the lower trunk mottled with patches of the older, darker bark. It is a massive tree, often 150 feet in height, with a broad trunk that tapers rapidly. In spite of its size, it does not grow symmetrically, but with its angular branches changing direction suddenly, it works itself into dramatic and erratic patterns. It usually does not carry a massive tent of leaves, and its branch system can be followed fairly well through gaps in its foliage.

Because of the angular and irregular characteristics of its branches, this is an excellent tree in which to study branch foreshortening. Separate studies should be made of branches coming sharply toward one, and of others receding.

As in all tree studies, the bark pattern should be accurately reported, but once the characteristic appearance is grasped, the bark mottling may be manipulated to fit the picture design.

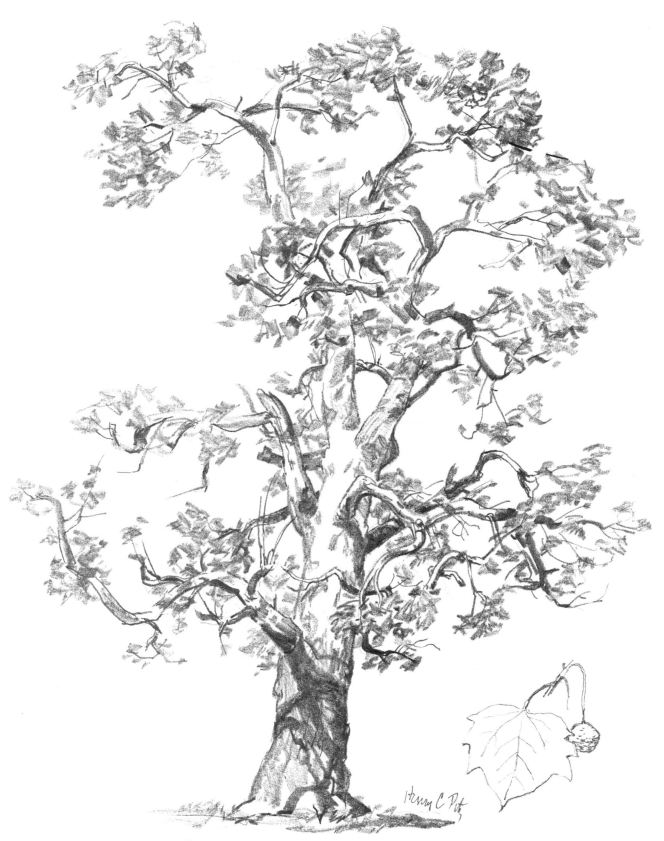

Sycamore
6B broad-edged pencil on cameo paper

The Bald Cypress

The Bald Cypress is a tree of such marked character that everyone notices it. It is also a symbol of a vast region, for it, together with the Live Oak (both festooned with Spanish Moss), stands for the Southland in many persons' minds.

The great chains of swampland that run from Maryland through the Deep South to Louisiana and Texas are Cypress swamps. From the water of these swamps grow the curious, fluted buttresses of the Bald Cypress. The wide buttress of the Bald Cypress trunk tapers to a tall shaft from which the branches jut at sharp angles. The foliage is composed of feathery needles which diffuse the light of the sky. This diffused light, aided by a curtain of Spanish Moss, throws an eerie light on the dark waters of these swamps so that all who see these swamps carry away a permanent picture in their minds.

Even more unique than its swollen base are the roots or "knees," which rise a foot or two above the water in a circle around the base. The knobby "knees" are roughly cone-like in shape, but sometimes they assume grotesque forms. Their function is supposed to allow the roots to breathe, but the botanists are by no means agreed about it.

This cone and needle-bearing tree drops not only its needles but even the twigs to which they are attached, so that in winter the Cypress swamp seems to be a flooded forest of dead trees.

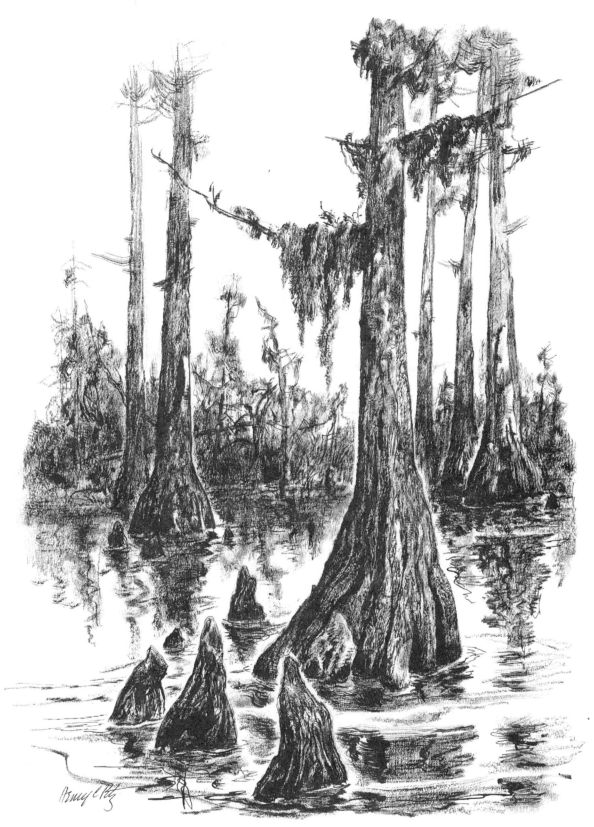

Bald Cypress
Drybrush on illustration board

83

The Dogwood

The Dogwood is one of the most beautiful and widely distributed of our native flowering trees. It chooses a propitious time for its blossoming, before most trees are showing green. Its large, white, four-petaled flowers are usually extended in layers from the trunk.

It is not a large tree, at its best scarcely forty feet high, and in the North often a shrub. It loves the edges of woodlands where it grows in the shadows of its taller neighbors. It has its glory in the autumn, too, for its foliage turns an eye-catching purplish-red.

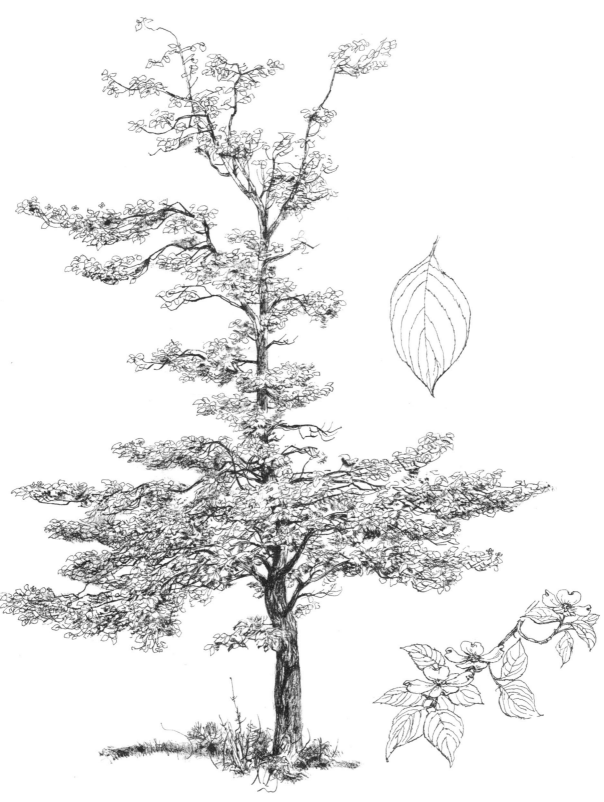

Dogwood
Pen drawing on illustration board

Roots, Stumps and Dead Trees

There are artists who, for some reason, seem to believe that only a perfectly formed tree, in its prime and covered with foliage, is worthy of their pencils. Trees are pictorially interesting at every stage of their growth, in every season, and even in death. Like people, they are likely to acquire character through vicissitude, and their life-struggle writes a history into their forms that stimulates the recording pencil of the artist.

Dead trees, still erect, extending the whitened wood and peeling bark of their shortened boughs against a background of sky or green foliage, are seldom without dramatic impact. And toppled by age or stacked by the wind, they offer the artist grateful horizontals and diagonals with which to build a more versatile composition. Like the living trees, they offer their own contributions of shapes, colors, and textures to the artist who is alert to enlarge his repertoire of design material.

Stumps, too, have pictorial fascination. Clean sawn by man, they present light-colored discs of heart wood rimmed with dark bark, or, crumbling with decay, they offer a gamut of disintegrating grays. Split and fractured by wind and weight, the splayed white splinters can be as beautiful as a flower form.

Roots, too, can be beautiful. They are not always concealed. On rocky or sparse soil, they crawl into view, sometimes in great serpent-like lengths. In an eroded bank, a web of intricate entanglements may be exposed, both a picture in its own right and an opportunity for taxing and rewarding draughtsmanship. The artist who becomes interested in root forms should search for storm-uprooted trees and study the great range of size and character between the filigree of the tiniest rootlets and the great tubular tap roots.

Broken branches and fallen leaves are part of the study of tree forms. The landscape artist soon learns how useful these are as foreground shapes. Landscape forms have been intently studied by artists for scarcely two centuries. It is still a young art, but, even so, in need of a renaissance. But that will require a new generation of fresh eyes and experimental brushes. The old lessons should not be forgotten but expanded.

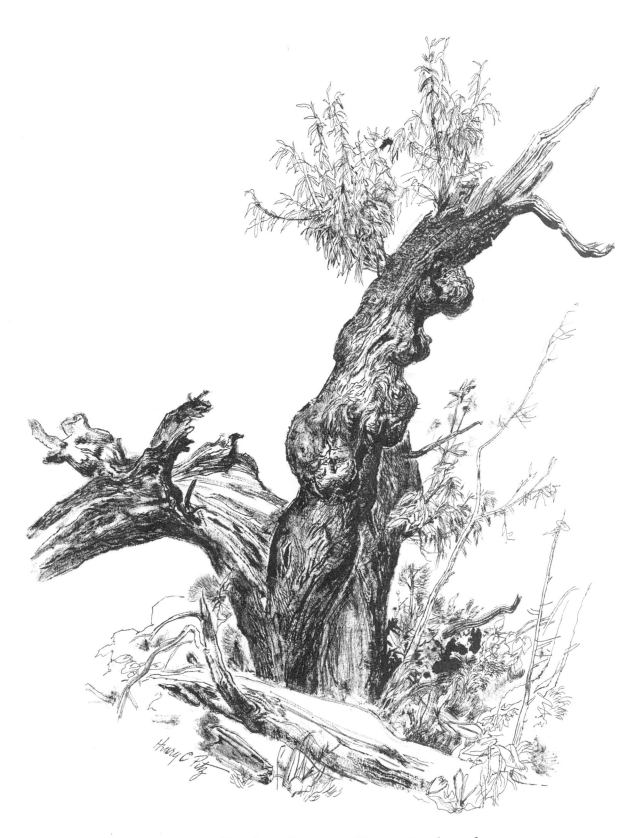

Drybrush and pen on illustration board

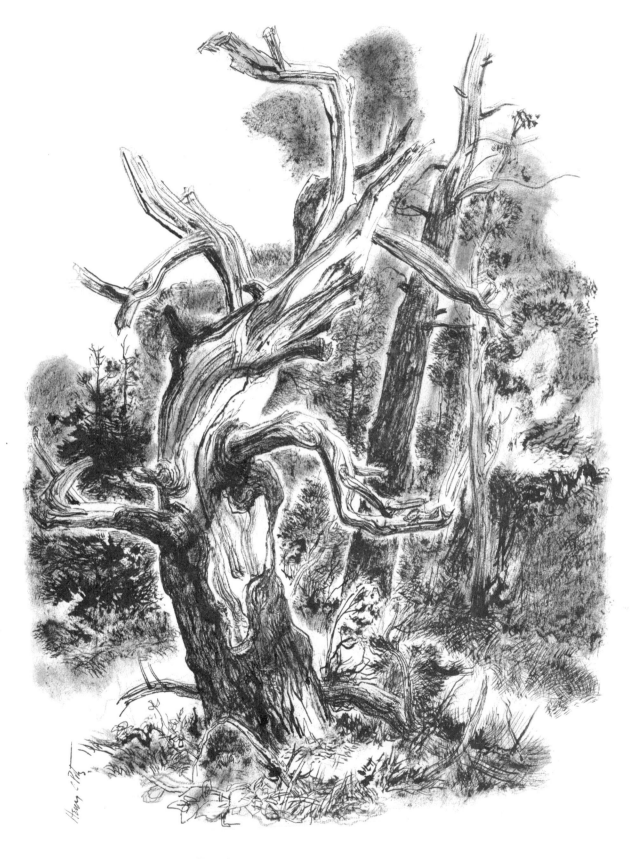

Drybrush on illustration board

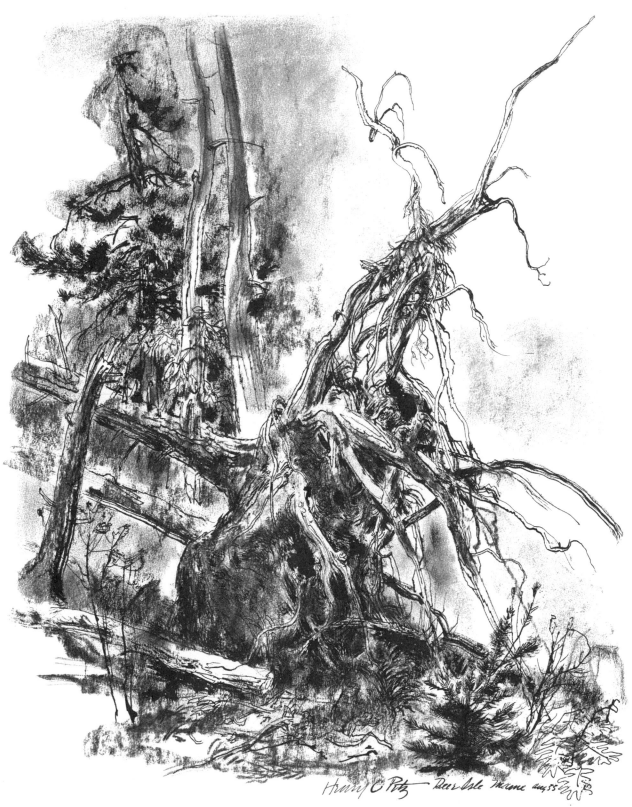

Uprooted Spruce
*Pen and ink and soft charcoal **on** illustration board*

89

Sketching Suggestions

Some artists are easily deterred from outdoor sketching because they have convinced themselves that it is a laborious operation requiring elaborate preparations and a great deal of time. Actually it is quite possible to accomplish a successful sketching trip in fifteen minutes. All one has to do is to pick up a small handful of materials, step outside the door, and draw whatever confronts one.

This is quite as likely to be as rewarding an experience as an hour's journey to some remote spot, followed by a search for "the right subject," and then a long journey back home. For the search for *the right subject,"* is often an illusion. *The right subjects* are around one all the time. They only require the right kind of seeing for discovery. And we discover the worth of a subject, not by a fleeting glance but by scrutiny and recording. If the student will take his subject matter on faith and draw, draw incessantly, draw what is close by, discovery will come.

If one is pursuing trees, of course, they may not always be at hand, but even in the city they can be found. Drawing an Ailanthus tree springing from a barren tenement yard can teach as much as sketching a perfectly formed Elm in a meadow.

Simplicity of equipment is of great importance to those who wish to avail themselves of odd scraps of time for sketching purposes. The sketcher in monochrome has a great advantage here. A few pencils, crayons or a fountain pen, an eraser, and a sketching pad or book, and he may be off. If he is a creature of comfort, he may want a sketching stool, one of the aluminum folding types that are small and weigh hardly anything. On the other hand, if he elects to sit on nature, a thick newspaper can be useful. Even carrying a bottle of ink and pens is not difficult, if the ink bottle has a tight screw top like the Pelican inks, and the pen points are removed from the holders and carried in a pillbox. Charcoal sticks also have to be carried in a box and the completed sketches made either on illustration board and fastened, face in, to another board with sketching pins, or thumbtacked face down to a drawing board and handled with reasonable care.

Of course the automobile can be not only a rapid means of transportation

to the artist but a mobile studio. It is a good but not a perfect answer to winter sketching. There are tree subjects just in the hedgerows that still line most of our country roads, and to draw them in the comfort of one's car is to deprive oneself of at least one excuse for making poor drawings. Trees are round the year subjects, and unless they are observed and drawn throughout spring, summer, autumn, and winter, they will not be understood and mastered.

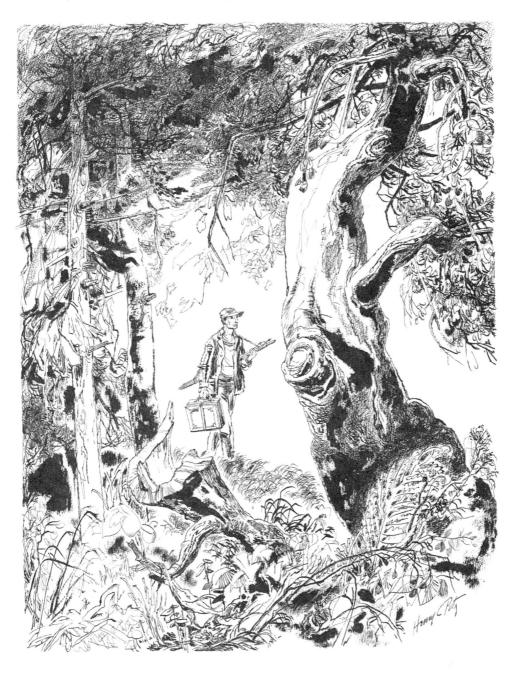

Pen, drybrush and lithographic pencil on D'Arches paper

Foreground, Middle Distance, and Distance

The sketching of individual trees is a fascinating and rewarding occupation, but most wish to use trees as major or minor motifs in landscape compositions. One of the first problems which arise is drawing a number of trees at varying distances from the picture plane.

Of course the laws of linear perspective tell us that objects appear to decrease in size in proportion to their distance from the eye (see the drawing on the facing page). There is also a law of aerial perspective which tells us that objects of the same local color become lighter in tone and less intense in color as they recede from the eye. It is important to remember that not all distant objects are lighter in tone than all near objects, for local color plays an important part. A distant Pine tree may be much darker than a nearby Willow because its innate deep green needles are much darker than the gray-green of the Willow foliage.

For a long time artists have been using three terms in talking of their problems in landscape depth: foreground, middle distance and distance. These are quite arbitrary classifications, and they have no precise boundaries, but nevertheless they are very useful terms in an approximate sense. The foreground is the area close to the picture plane. Middle distance may be about a hundred yards off, or a quarter, or a half mile away, for, as its name indicates, it is about midway between foreground and distance and varies with the depth of the picture. Distance could be the shimmer of horizon twenty miles off as seen from a mountain, or a hill cutting the sky a quarter-mile away. There is solid ground and many other things between these areas, and the artist is not oblivious of this, but landscape composition is a matter of selection, and the most important elements are likely to group themselves in one or more of these areas.

Because it is so easily changed, charcoal is an ideal medium for experimenting with this problem of the degree of grayness, and of definition of near and far trees. A master may indicate a distant bank of trees by a gray smudge, but it would be a smudge of the right value, shape, and character. The student must develop the skill of creating light tones that contain a hint of tree form but do not overstate it. In the middle distance, his form will become more assertive, aided by darker grays. In the foreground, the forms may be modeled to their

fullest, and certain details of tree structure emphasized as much as he cares. A series of drawings showing the development of distance, then middle distance, and then foreground, is shown on the facing page. It will be noted that the areas between those named contain a suggestion of contour and detail to tie the composition together, but that the important compositional elements step back from foreground, to middle distance, to distance.

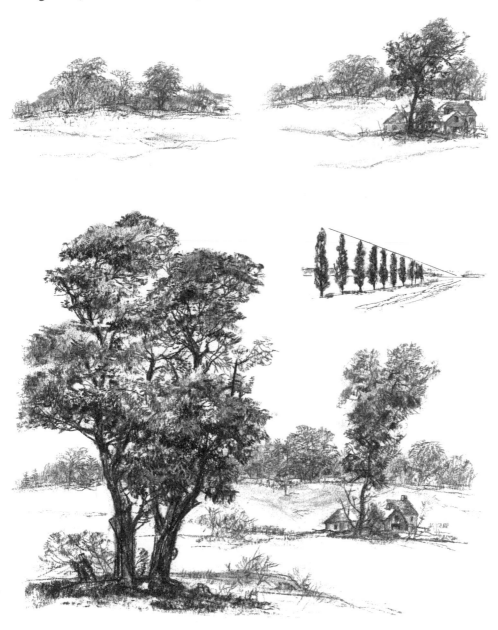

Distance, Middle Distance and Foreground in Three Stages
Soft charcoal on illustration board

93

Trees in Landscape

Although the student should spend many intent hours of study drawing individual specimen trees, this should be interspersed with sketching all kinds of landscape compositions. Drawing individual trees alone may lead to more than usual bewilderment when confronted with trees in the mass.

The most important thing to remember, when about to draw any segment of landscape, is that the artist has the power of *selection*. He should be in command of his composition. From the bewildering array of forms before him, he must decide what things are most significant to him and either subordinate or ignore all the other shapes. A picture is a series of *decisions* — emphasis, and elimination — and the student must begin making these for himself if he is to become a creative artist.

If the student can manage to study the same landscape at different times of the day, from early morning to dusk, he will pick up some tricks of selection from nature, for light is a great emphasizer and subordinator.

There is often a tendency to look for the perfect composition. This search can be a waste of valuable time. If the student will begin sketching the first scene that interests him, he may engage in the struggle of making a perfect composition with the material before him. The struggle will produce more lasting good than the search for a ready-made picture.

The power to compose, like the power to draw, comes from doing. There are books on composition and they may be a partial help, but we live in an age in which new ways of seeing are being born. All the old so-called *laws of composition* are still good, but they are being modified and extended. When, after trial and error, our age has hammered out its compositional pattern, there will be those who will codify and classify the new findings.

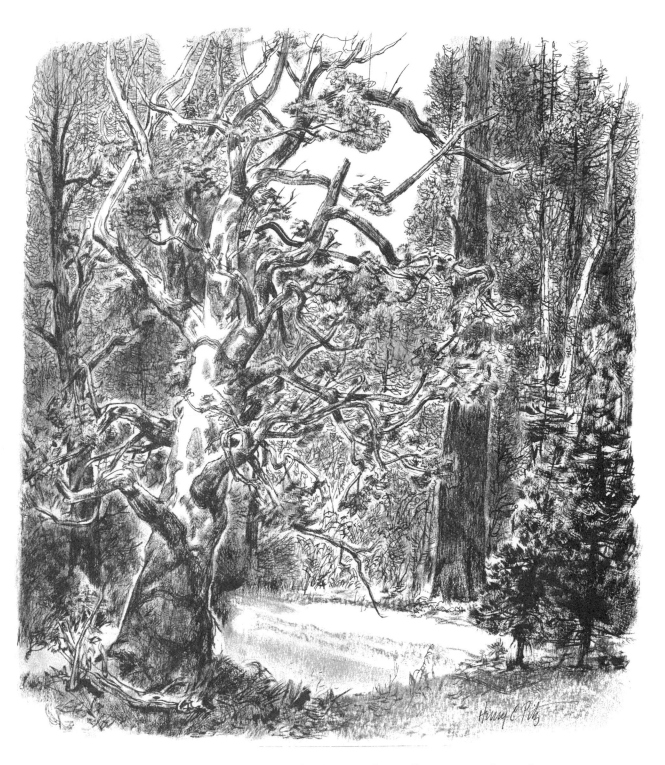

Drybrush, pen and soft charcoal on illustration board

Trees in Mist and Fog

Trees are anchored in the earth and they are there whenever we care to interview them with sketchbook in hand. But they are not inert, changeless entities. They have moods. Their moods respond not only to the seasonal cycle—from the bare boughs of winter through the experimental greens of spring, and the canopy of heavy summer foliage to the bright and fading colors of autumn—but they respond also to hourly shifts of light and every whim of weather.

We can scarcely hope to understand trees until we have followed them through mist, snow, rain, wind, and heat; through early light and its last fading; and through the seasons. By studying trees in various situations, we will greatly expand our resources not only in depicting trees in particular and landscapes in general, but in creating the broadest repertoire of pictorial possibilities.

Mist and fog are capable of producing a fairly wide variety of effects. Mist and fog clothe the familiar scene with a veil of unreality. They can distort, mystify, and obscure. Mist can rise from a river or another body of water and gradually rise toward a chain of hills. Mist can shred out in long streamers at various levels of the atmosphere or coil around a high hill while the lower reaches are clear. Fog can descend or move in like an engulfing wall.

Mist and fog always tend to reduce contrasts, softening forms and creating a monotone world. The monotone world in the picture was depicted in a light tone with soft charcoal, gently rubbed with the finger. Into this tone, the darker forms were indicated, sometimes with the broad side of the charcoal stick.

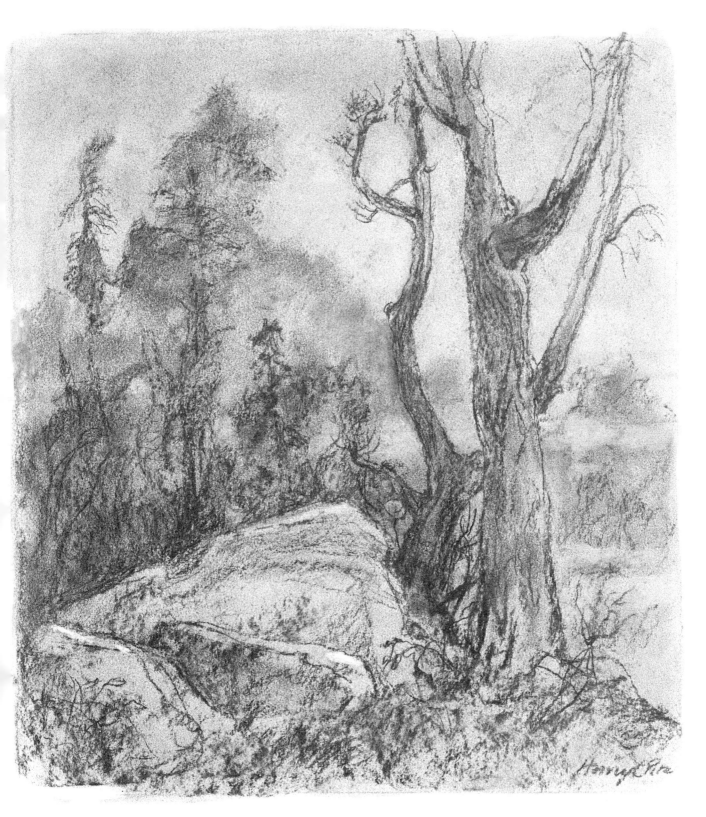

Trees in Mist and Fog
Soft charcoal on illustration board

97

Trees and Snow

Like mist and fog, snow has the power to transform the familiar. A transformed world certainly is the experience of childhood, and it would be well for an artist never to lose that sense of a strange and incredible world.

Like many of the drawings in this book, this drawing was executed in soft charcoal because of the great malleability of the medium. Tones were built up quickly, reduced, or modified with a touch of the finger, and defined with a few strokes of the charcoal stick. On good quality drawing paper or illustration board, manipulation of tones could go on almost endlessly. Charcoal is a perfect medium for the experimenter.

Basically, the forms of the tree and the small shrubs were drawn in swiftly with the blunted point of a soft charcoal stick and left almost untouched. The background of sky was drawn in with parallel strokes and gently rubbed into a tone with the finger. The upper edge of the branch system and the branch junctures, where pockets of snow accumulated, were left paper white. That is essentially the story of the under drawing.

The falling snow was a spatter of white watercolor. Bristles of an old toothbrush were coated with a very thin creamy paste of white watercolor pigment (not too much water was added). The bristle end of the toothbrush was held upright and it was aimed at the picture—about six or eight inches away. A knife edge was drawn across the paint-charged bristles away from the picture surface. A spray of flecks of white pigment was the result, with the maneuver repeated as many times as necessary.

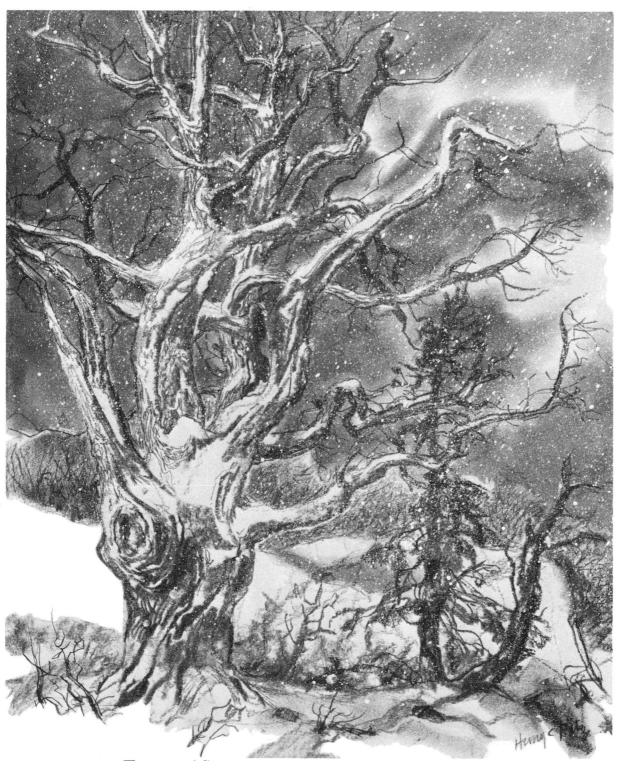

Trees and Snow
Soft charcoal and watercolor on illustration board

Trees and Rain

How often do we hear of artists painting or drawing in the rain? Most people would consider this slightly mad, and yet we live in a world liberally supplied with doorways and windows, sheds and awnings, and—best of all—automobiles.

The gamut of the types of rain is considerable, ranging from the almost imperceptible veil of a gentle drizzle to a blinding cloudburst. Like mist and fog, rain brings about a contraction of the tonal range, mutes the distances, and tends to blur forms. When our subjects contain hard, nonabsorbent surfaces, we can expect a dazzle of reflecting lights gleaming from those wet and glistening, mirror-like planes. Trees and their surrounding areas do not usually present such mirror-like surfaces. If the soil of an area under a tree is not too absorbent or sloping, any depression will collect a pocket of water and a mirror is created.

In certain lights, the dripping leaves of the foliage masses act like tiny mirrors and a thoroughly soaked tree trunk sometimes reflects a ridge of light. The bark of many trees darkens considerably when rain-soaked. The ordinarily middle-gray bark of an oak appears blackened on one side by a driving rain while the dry side seems lighter than usual by contrast.

In the case of the heavier types of rainfall, the artist often relies on the familiar pictorial device of suggesting the slant of rain by running his brush or crayon marks in the same, general direction, leaving streaks of tonality between. This device is effective if not made too obvious.

No rain picture would be considered complete without a rain puddle. One can always be invented to accent a picture.

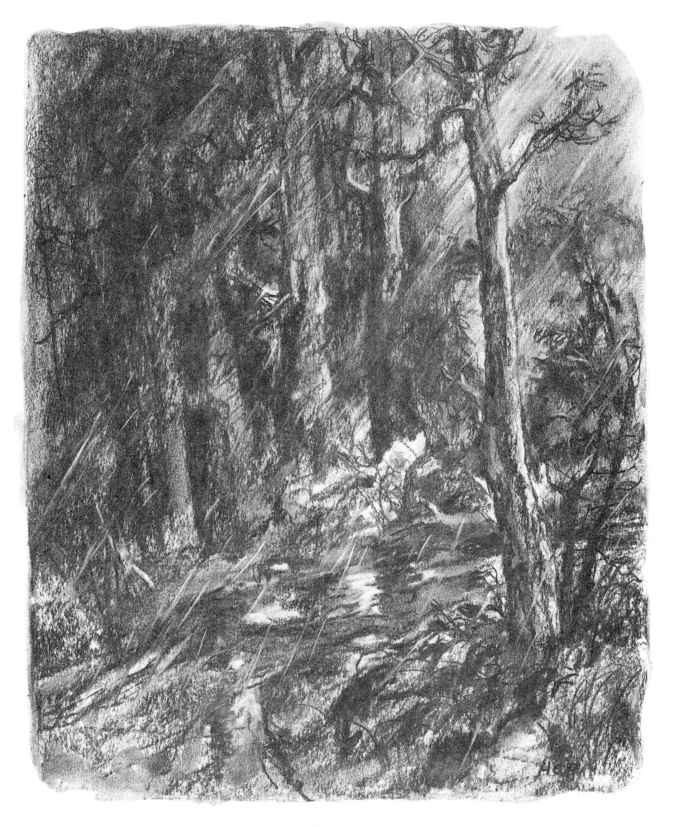

Trees and Rain
Charcoal on illustration board

Trees and Water

In our concern with drawing trees for the sake of mastering their forms, there is a possibility that the tree may become an isolated organism. Of course, the tree belongs in the world. A tree is a significant part of the great plan of nature and is just one of the countless forms that invites the artist's brush.

When the artist combs the countryside for pictorial subjects, he is likely to be attracted by water. Water, in combination with trees and other natural or man-made forms, is very attractive. Water is a mirror but a capricious one. It reflects the overhanging sky and all forms on or near its borders—if conditions are right. The ideal condition for reflections is absolutely still water, but this is not its usual condition. Still water will reflect an upside down duplicate of the trees at the water's edge, each reflection appearing directly under the objects reflected. Objects near the margin reflect their upper portions; those more distant do not reflect at all. The slightest current or wind ruffle will distort and fragment the reflected image. The swirling images produced by any water disturbance is the great fascination of water reflections.

The artist who observes and records the caprices of water soon discovers other elements that modify the water's appearance. Although water is normally translucent, and sometimes in shallow conditions it reveals the shapes and color of its bed, there are some conditions that add color and opacity to it, such as the mud content of flood waters or the amber stain of cedar swamps. All in all, water is too mysterious an element to yield all its secrets in a few sketching expeditions.

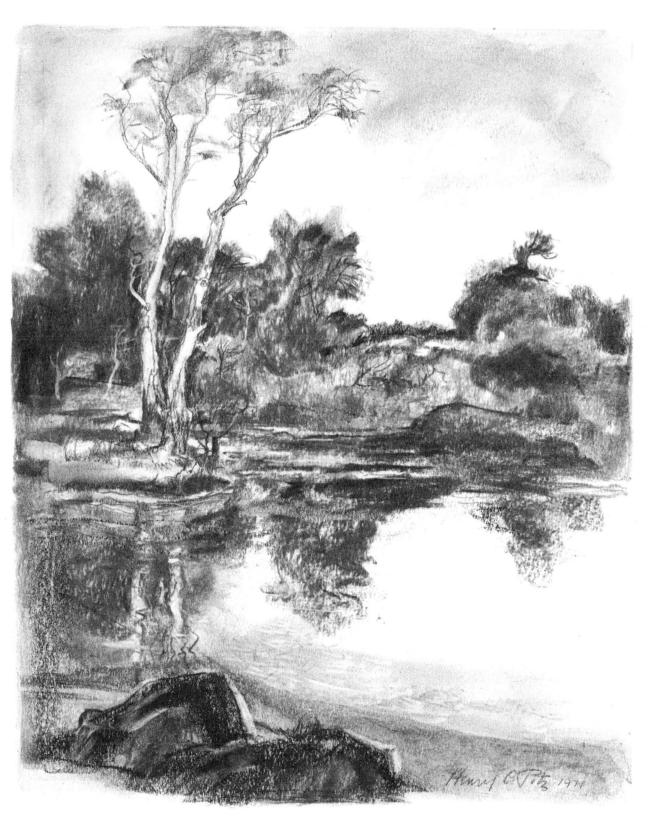

Trees and Water
Charcoal on illustration board

The Fallen Tree

Most artists have a vertical concept of trees, and rightly so. We love to see trees springing from the good earth and reaching for the sun. Our landscapes are filled with these verticals.

But often our compositions develop a craving for horizontals and diagonals. We search for slanting rocks, bits of steep hillsides, and level clearings. We ignore the occasional fallen tree or bough. Why are they so often considered irrelevant or ignoble motifs? To the appreciative eye they disclose strange and unusual beauties. And they add an unhackneyed element to the artist's vocabulary of forms.

There can be something majestic about a great, fallen tree and there can be much that is pathetic about the smaller ones. Lying aslant the verticals of their living kind, fallen trees symbolize one of nature's life spans. A little patient observation and delineation in a sketchbook will reveal unexpected beauties.

Shallow-rooted trees may topple and tilt up a great pan of soil clinging to the roots. As wind and weather begin their work, the soil is gradually eroded, exposing the writhing entanglement of roots. Presently, the bark flakes away and trunk, bough, and root are bleached white by the sun. And a white, fantastic form is revealed against a dark background of living green. That should excite our pictorial eye.

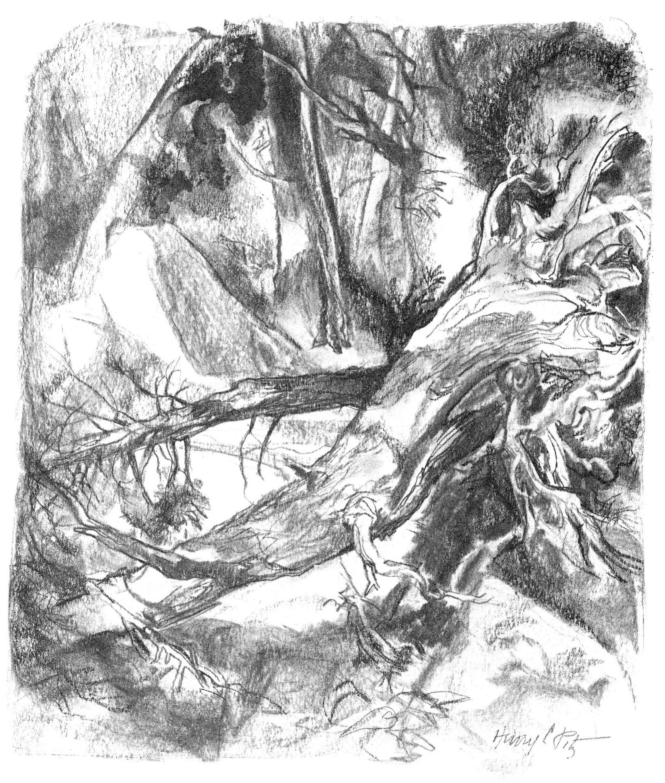

The Fallen Tree
Charcoal on illustration board

The Ground under Trees

It may seem tiresome to reiterate that trees do not begin or end at the earth's surface, but too many artists draw them as though they do. Trees penetrate that surface, and their life and character depend upon what they find in the subterranean depths.

In shallow soil, their probing in depth is balked; they spread out their fan of roots and often portions of this network shows on the surface. On rocky surfaces, whole networks of roots may be visible, as if the roots were searching for some crack or cranny in the hunt for nourishment. In deep and rich soil, the roots tend to slip in with only a slight thickening of the trunk.

The trees, in turn, condition the soil beneath them. They are heavy feeders, and large trees impoverish the soil beneath their roots, stealing nourishment from the frailer grasses and surface plants nearby. The amount of shade trees cast is also a factor in what grows around their trunks. Heavy shade cuts down drastically or entirely the growth of surface plants. Trees with light and light-penetrable foliage may permit a carpet of grasses and weeds to grow under their boughs.

In these drawings, the upper one is of the trunk of a Norway Maple, which casts a dense shade. Only a few feeble grass or weed shoots survive into the summer months of heavy foliage. The ground below, screened from the burning sun, is more friable and moist. The lower drawing of the trunk of a Double Birch shows how a much smaller tree, with light and open foliage, permits a covering of bracken and field plants to creep up to the trunk itself. Something of the story of a tree is written in the ground beneath its boughs.

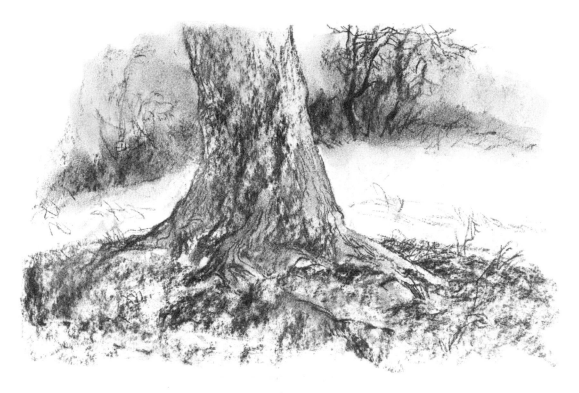

Norway Maple
Charcoal on illustration board

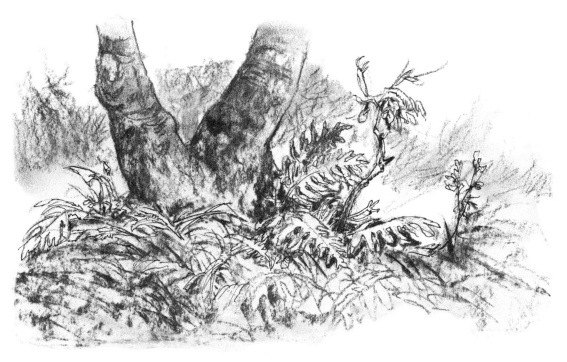

Double Birch
Charcoal and ink on illustration board

Trees and People

In writing this book on drawing trees, I am tempted to adhere closely and exclusively to the stated subject, to tacitly suggest that tree forms are of first importance among all the innumerable forms of the natural world. But what artist—whether a painter, an illustrator, or a designer—concerns himself exclusively with trees? The tree is a noble and fascinating form, but in both the natural world and the two-dimensional world of the artist, it plays its part in combination with other fascinating forms. A few remarks about some of the many combinations possible to the artist will open some doors into the realm of pictorial expression.

In spite of the prevalence of abstract forms in today's art, the human form is still of first importance. We are not likely to lose interest in our own kind. The human form and trees, then, is a usual combination. Let us admit, at the beginning, that the human figure is more difficult to draw than a tree, which is the reason some painters are chary of introducing a figure into their landscapes, but for those who are competent draughtsmen, the figure adds another dimension.

The combination presupposes the outdoors: a common light falls on both tree and figure; they react to and upon each other as all elements must do in any composition. Their sizes relative to each other immediately establish a scale that pervades the picture.

The etching on the facing page is an excellent illustration which shows a fine unity of time and effect. The bright sunlight falls impartially on trees and figures; it dances its way through the leafy canopy and flickers over the moving bodies below. Without being overexplicit, an effect of nature, a place, and a way of life are revealed—all in a lighthearted technique.

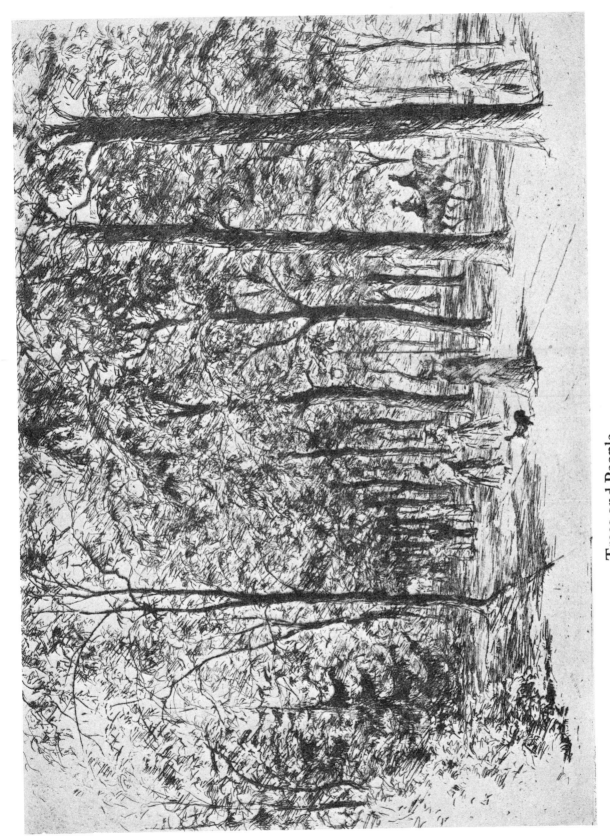

Trees and People
"Zoological Landscape" by Hans Meid
Etching

109

Trees and People:
Decorative Interpretation

A desire to depict things as they might happen rather than as they do happen occurs to a few artists sometimes and to other artists all the time. This design sense is the instinct to use nature's material to conform to an imagined pattern, to organize elements into a decorative aspect. In such an interpretation, something is lost and something is gained. It is a choice dictated by the type of the artist's talent.

In the lithograph, the figures and the jungle setting are united by a design of black and white spaces. Detail has been sacrificed in the interest of a strong contrast of black forms encircling white areas. The rhythms of the tree and plants have been controlled to the same end and the two human figures were simplified and silhouetted against the central white areas to emphasize the effect of blinding sunlight pouring into a dense, dark jungle.

Decorative Interpretation

Trees in Illustration

The illustrator is a special breed of picture-maker. The demands of his profession are such that he is likely to develop considerable versatility, an ability for rapid execution, a command of a wide range of pictorial material, and the self-discipline to produce under what are sometimes difficult and hurried circumstances. Normally, he is supplied with his themes and sometimes they are very restricted ones. Sometimes the subject matter given him is new and strange and he must acquire a working knowledge of it in a short time.

Needless to say, the illustrator must possess a high degree of skill and a temperament that is not indecisive or prone to fumbling. To the illustrator, trees are familiar forms. He has used them many times in many ways and, although the human form is almost always his major motif, trees are still favorite and greatly prized adjuncts to his figure compositions. Even when the text he is illustrating does not demand trees, he will often use them to enhance the design of his pictures.

There is a considerable variety of personal styles in the field of illustration, but even the most imaginative and decorative of them spring from a command of the familiar forms of the visible world. Even the obviously realistic styles often have an element of decoration in them because the illustrator's picture hardly ever exists by itself. It finds its place on a book or magazine page, almost always surrounded by or adjacent to areas of type. This design encourages the development of a design sense.

The double-page book illustration developed from the first small composition sketch into a full-size pencil drawing on tracing paper. All the important forms were carefully delineated. This drawing was traced onto a sheet of illustration board and the principal forms defined in ink. A few touches of watercolor were added, and then tones were introduced over the ink drawing with soft charcoal. This method allows experimentation and adjustment of tonal values without harming the underlying drawing. The tones of soft charcoal can be modified repeatedly without obliterating the ink lines that define the basic drawing. Once the tonalities are adjusted, the tones are sprayed with fixative.

This illustration is basically a realistic picture with some undertones of decorative composition. The trees are an indication of the forest in which this incident took place. The center of interest—the clump of riders and the wild man—is placed to one side of the panel because this is a double-page book illustration that is fastened to the binding down its center. All major forms are kept away from this strip to prevent distortion where the sheets curve into the binding. (The illustration shown here is reproduced and reduced from *The Chronicles of Froissart,* published by the Limited Editions Club, 1959, George Macy Companies, Inc.)

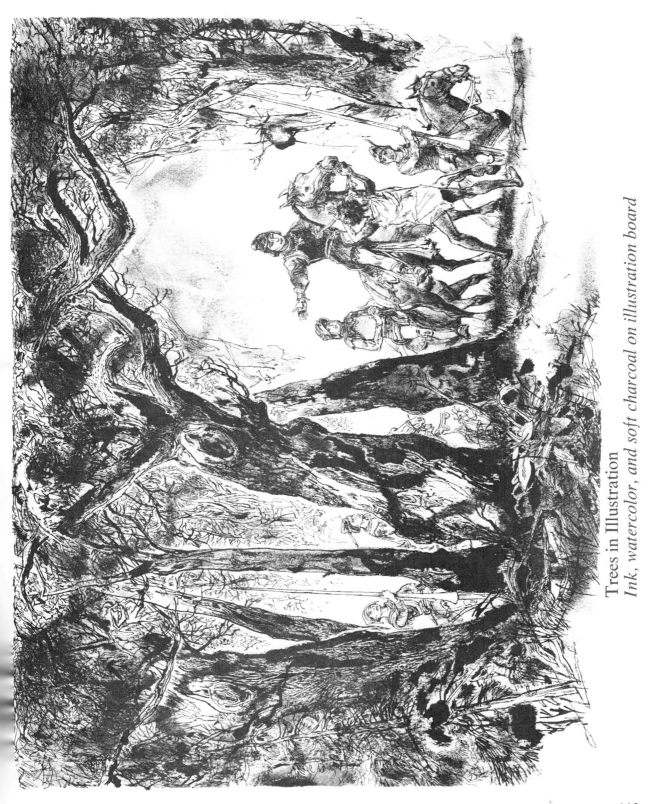

Trees in Illustration
Ink, watercolor, and soft charcoal on illustration board

Trees in the Direction of the Decorative

The illustration shown here, in comparison with the preceding one, is certainly still in the area of representational delineation and represents a step in the direction of the decorative. This is largely due to the medium selected: pen, brush, and India ink.

Each medium that the artist selects brings its own persuasions to bear upon the resulting picture. In addition, the particular reproduction process chosen has an important influence upon the resulting printed image.

In this picture, the subtle gradation of gray tones from palest gray to black—which is possible in mediums like charcoal and paint, beloved by realistic artists—was not entirely possible. Tones can be suggested only by hatching ink lines more or less closely together, which means that the ink palette of grays can only manage a gradation of about five tones. Tonal simplicity is the portion of the pen picture and this tends toward a decorative effect.

In addition, the usual free use of outline tends to give a decorative aspect to a picture. Finally, the use of large areas of black for the darker values has the same result. Although its three figures are realistically drawn, this illustration gains a certain decorative aspect because of the simplicity of the dark background, the snow areas, and the design value of the gnarled tree. (The accompanying illustration is from *Sprigs of Hemlock,* published by The Century Company.)

Trees in the Direction of the Decorative
Pen, brush, and ink on illustration board

Trees in Decoration

This illustration is completely decoration. It is a design for the front and back end papers of a book devoted to a story of the Vikings.

The panel is a chart-like decoration intended to convey a feeling of Viking exploration, of strange coasts and of strange waters. The trees are reduced to design symbols; the water ripples are arbitrary. Ink again was the medium, used in thick line and heavy darks. A second plate, used perfectly flatly and printed in a medium tan ink, backed up the key drawing.

The change in the treatment of trees in this and the preceding two illustrations should, hopefully, open up a curiosity for you about the handling of tree forms by other artists.

Trees in Decoration
Printed end papers

Trees and Rhythm

A tree is not to be drawn with a straight edge!

One of a tree's most fascinating qualities is the rhythm of its growth. Each tree is an individual, expressing the factors of its species, its location, its weather, and its age. Its rhythm may be subtle or dramatic, but the variations within that range are infinite.

Apart from the problem of capturing these rhythms with pencil or brush is the alluring possibility of allowing them to penetrate and invigorate the creative mind, to permit this accumulating knowledge to spur and enlarge the artist's compositional sense.

It is one experience to draw with accuracy a standing tree; it is quite another to place it in a composition of our own invention and command that form to do the behest of our pictorial desire. Although the ability to draw trees accurately is important, its true value expresses itself in the artist's ability to use that knowledge to invent, transform, and command those forms to enhance a picture. After an extended experience of on-the-spot studies of many kinds of trees, the artist should be able to draw them from memory and modify them to fill the compositional needs of pictures.

This lithograph evolved from a more literal, brief sketch. Upon the artist's contemplation of the sketch, more dramatic rhythms began to assert themselves and so they were allowed to be incorporated. Although the rhythms of the tree forms are obvious, it should be noted that rhythm is not solely a property of form; there is also a rhythm of lights and darks.

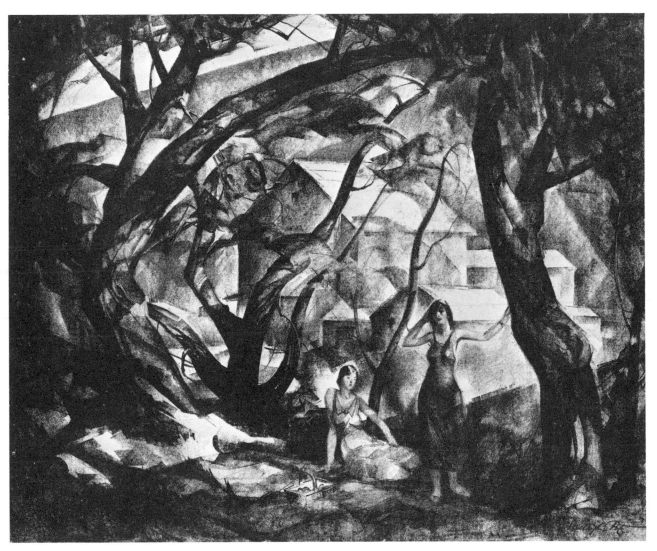

Trees and Rhythm
Lithograph

The Imaginary Tree

After so much of my repeated insistence on recording the natural shapes and characteristics of trees (which can well be a lifelong pursuit), it is well to open another door and consider another approach to utilizing our knowledge of tree forms. This is to put our imagination to work upon our acquired knowledge of trees and see what happens. There is nothing new about this—it is an ancient practice and we haven't outgrown it.

Our ancestors believed that trees had spirits, that elves and other part-human creatures had their dwelling places there, and this belief is undoubtedly in our blood. Science and calculating industrialism have not obliterated fairyland; versions of the ancient tales are still in our children's books, supported by a galaxy of imaginative creatures. Arthur Rackham, a famous British illustrator of not so long ago, was known for his pictures of gnarled trees that took on weird shapes of half-human beings, and his books are now collector's items.

This doorway into the world of the imagination, where we meet beings and trees that cannot be found in textbooks of science and the encyclopedia is not for everyone. It requires a suspension of belief and an acceptance of the unexpected. The rewards are many.

The new, the bizarre, and the fantastic, however, do not shape themselves out of nothingness; they grow from the old and accustomed. Choose a familiar tree form; let your pencil and your mind move over it, through it, and beyond it. Be willing to follow any clue the pencil turns up. Be hopeful but undemanding. Nothing may happen, but sometimes a miracle occurs. (The accompanying illustration is from *Charcoal Drawing,* published by Watson-Guptill Publications.)

The Imaginary Tree
Soft charcoal, ink, crayon, and carbon pencil on D'Arches paper

Trees as Linear Pattern

Man is a born maker of patterns, and over the ages he has drawn the tree in countless forms of pattern and as a symbol. Today the tree as a symbol is still in widespread use since it is a form that really lends itself to both simplification and elaboration.

One of the influences of modern art has been to reawaken man's innate sense of design and encourage it to evolve new and strange forms. So even the most literal and matter-of-fact artists feel not only the pressure of being discontent with recording what the eye sees but also the incentive to allow the mind to dictate its interpretation.

No matter what an artist's predilections may be, it can be a fruitful experience to take one of nature's forms and play variations upon it. For many artists, a good approach is to reduce such a form to a linear pattern. It does no harm to follow any pictorial whim or notion. The results might be trivial and empty—or perhaps astonishingly rewarding. However, it is a worthwhile experiment.

The accompanying design began as a rambling, involuted charcoal line suggested by the feathery quality of foliage. The fingers of the artist led the way with the charcoal stick; his mind watched to see the results.

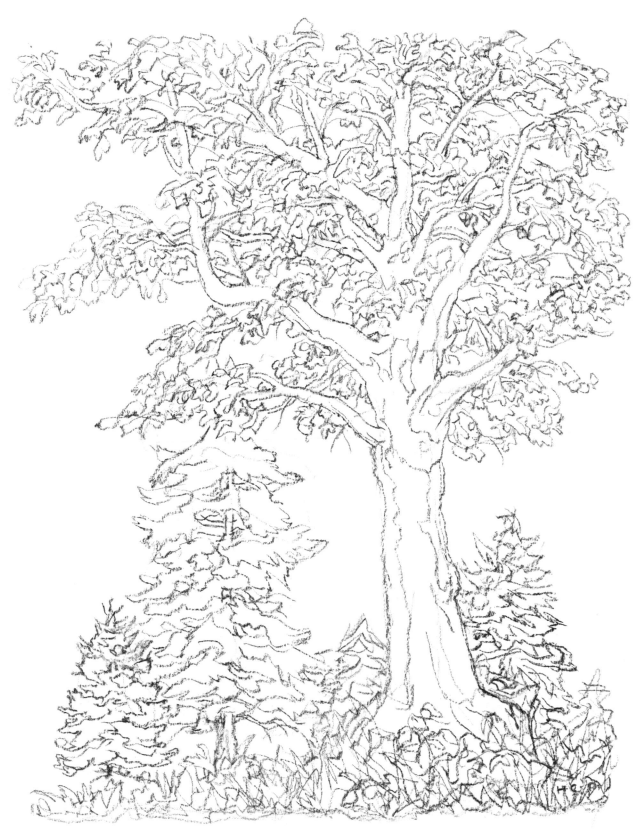

Trees as Linear Pattern
Charcoal on illustration board

123

Trees as Decorative Pattern

The preceding illustration of pattern was tentative and exploratory, and charcoal was the selected medium because of the ease of its response. This page of tree designs was executed in black line and mass, suitable for more positive and pre-thought-out forms.

These tree motifs are direct and clear-cut. They can be used on the printed page in many ways or they can be adapted to quite a number of different materials. But a good deal has been taught from the exploratory procedure of the preceding exercises. Both procedures have their values, but combined they stimulate each other and make for growth.

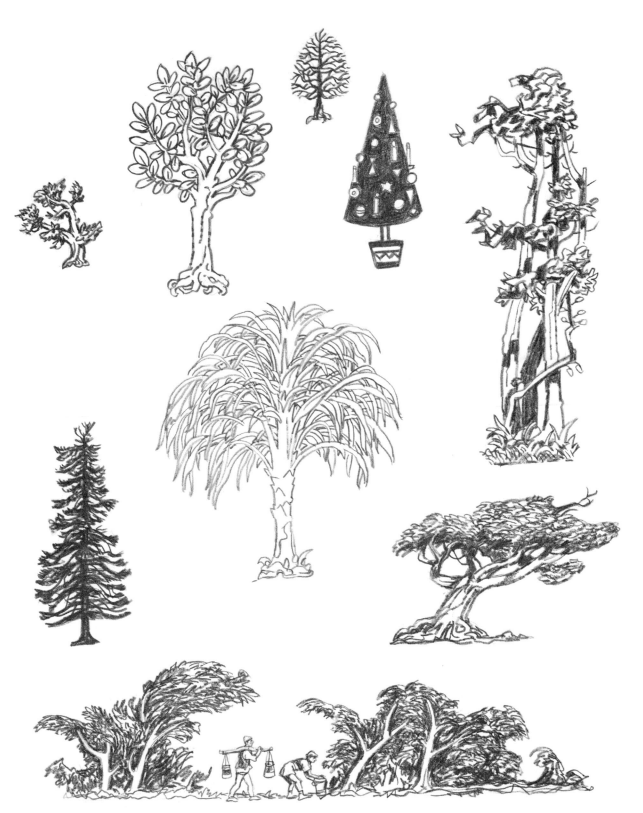

Trees as Decorative Pattern
Charcoal on bond paper

125

Trees as Abstract Pattern

Abstract forms can spring up under the artist's brush or pencil in many ways—full born or tentative. The standard way has been inherited from the pioneer giants of modernism—Pablo Picasso, Georges Braque, Paul Klee, and others. This way consisted of utilizing the common objects of everyday life, simplifying them, arranging them, changing their shapes at will, until little or sometimes no trace of the initial forms remained in the final result. From this procedure a new dictionary of forms evolved.

The accompanying abstraction has followed this procedure. From a sketch of three trees with an entanglement of branches and the sparse foliage of autumn, the material was left to the groping of a partially conceived design, lurking in the mind's eye.

Through a series of experimental changes the abstraction developed with only the smallest evidence of its beginnings.

It is interesting to note that in late years a reverse procedure has been spreading. Many artists inclined to realism, anxious to enliven their perception of natural forms have laid in their canvases with completely abstract shapes. When an arresting arrangement has come about, they study and brood over it to discover how shapes from visible nature can be suggested in these shapes. A goodly number of exciting paintings are developing from this approach and what could be more natural than this cross-fertilization of tradition and modernism?

Trees as Abstract Pattern
Charcoal on illustration board

A GROUP OF TREE DRAWINGS

Here are a number of essays in varied techniques in the problem of drawing trees. Sooner or later the student should try all reasonable techniques; the finding of one's own ordained technique almost always calls for an apprenticeship in trial and rejection.

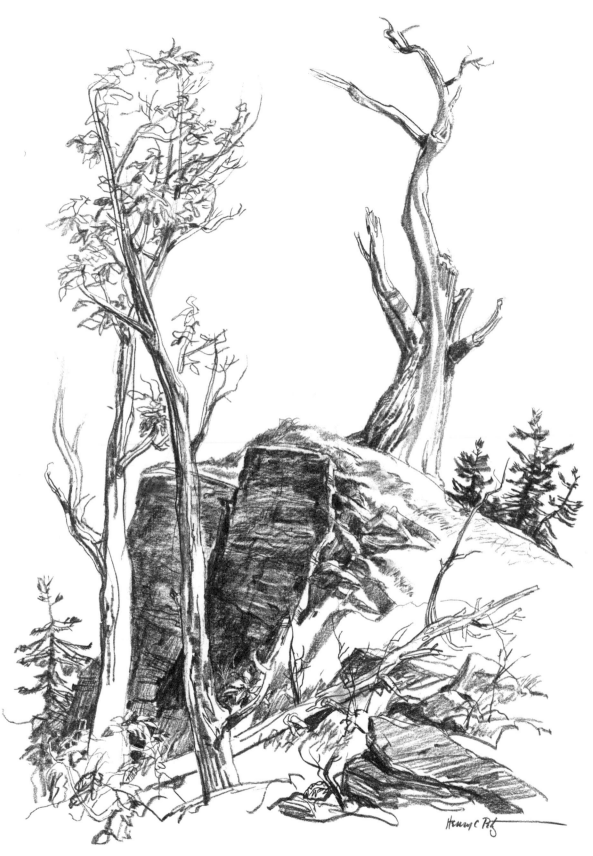

Carbon pencil (4B) on media paper

129

Soft charcoal, with touchs of pen line on illustration board

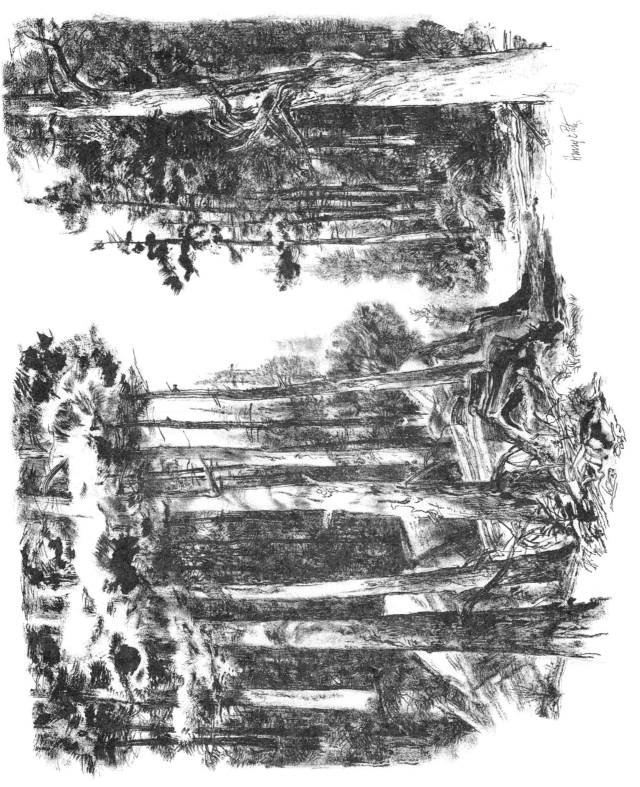

Drybrush on illustration board

131

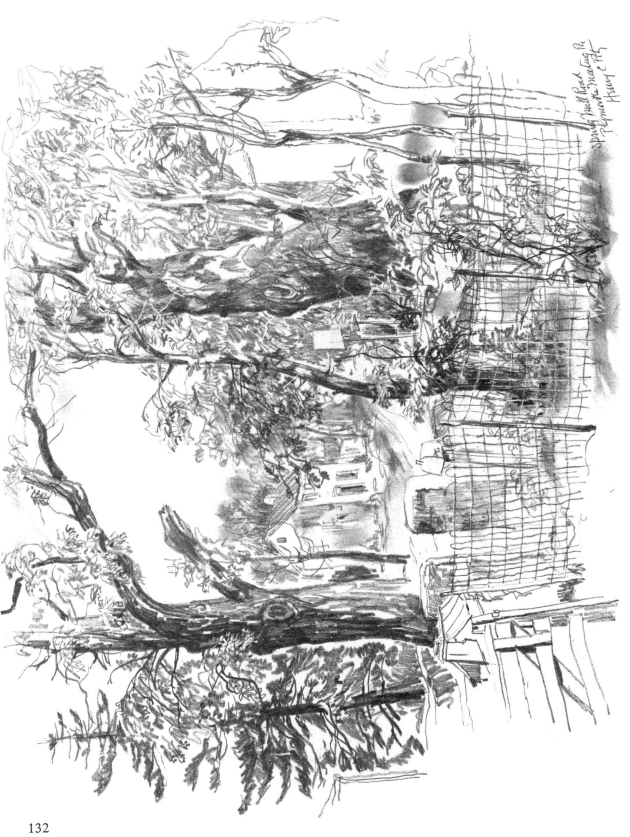

6B pencil on cameo paper

132

A GALLERY OF EXAMPLES
By Various Artists

Here are twelve drawings of trees done by twelve artists of the
past and present. A study of them should disclose to the student
that the drawing of trees, like any other graphic expression, is,
in the end a personal thing. That is the goal of all artistic study,
to have something personal to say about one's chosen subject and
to say it in one's own way.

RONALD SEARLE
Drawing from Paris Sketch Book

RONALD SEARLE is one of the most gifted and brilliant of England's graphic artists. He is young, vital, prolific and greatly accomplished. His drawings are spontaneous in their masterly ease and they all say something, something amusing, penetrating or biting about human nature. His sketching instrument is usually a fountain pen filled with wood stain. When dry the stain can be smudged with a wet finger. That is the way this lively drawing was made. It is taken from his *Paris Sketch Book,* published by Saturn Press. The book is filled with drawings of a captivating freshness and deserves to be on the shelf of every student and graphic artist.

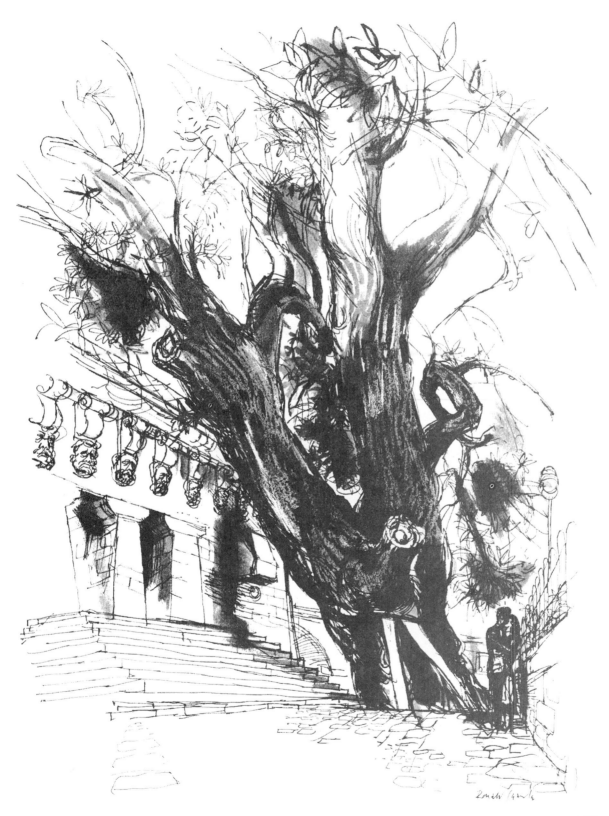

STOW WENGENROTH
Black Oaks

STOW WENGENROTH has for years been one of America's finest lithographers. His drawings are not as well known as his lithographs but they deserve to be. He makes them as studies for future lithographs but they are works of art in their own right. This drawing of Black Oaks shows how precise, detailed and yet spontaneous the drybrush technique can be.

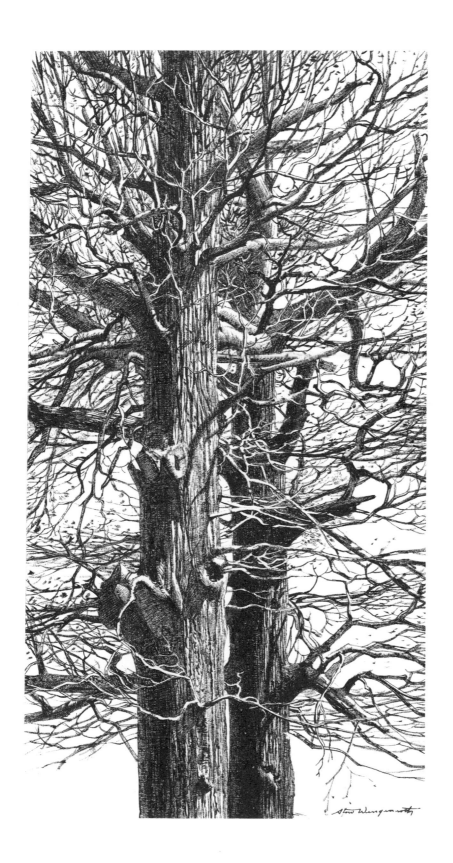

ALBERT GOLD
Tree Trunk

ALBERT GOLD is one of the comparatively few strong draughts-men among the younger painters and graphic artists. He is better known for his paintings of the human figure against an urban background but here is a fluent brush statement of an old willow trunk. Sepia watercolor, used both wet and drybrush, is handled with confident skill and freedom to report the warty form and corrugated texture of an old tree.

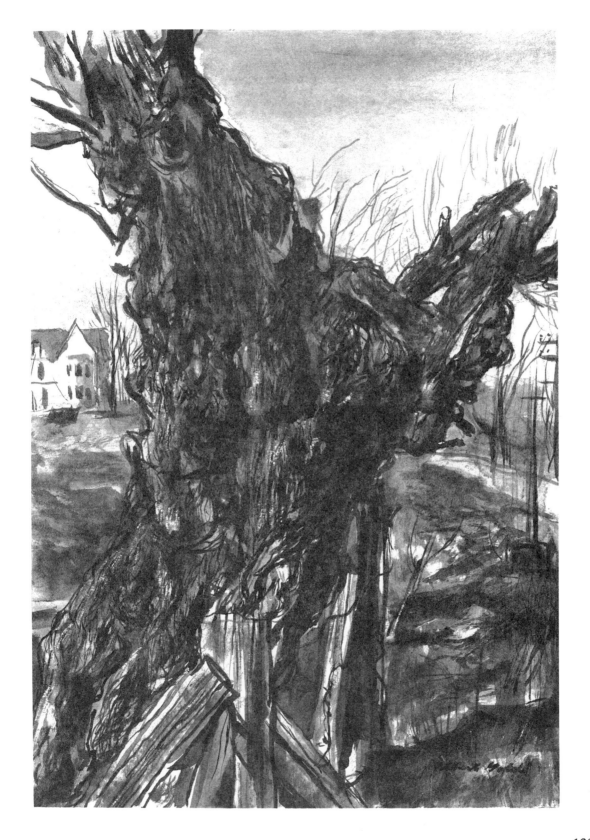

ANDREW WYETH
Along the Brandywine

ANDREW WYETH is one of our most important artists. His best pictures disclose layer upon layer of profound and revealing emotion. Underlying these pictures is a structure as firm as granite. A sense of this structure is in his drawing of sycamore or buttonwood trees. It is a large drybrush drawing which suffers in reduction. The scaling bark is beautifully expressed, the trunk and branch silhouette is a handsome design and the whole is an accomplished pictorial document of the southern Pennsylvania countryside.

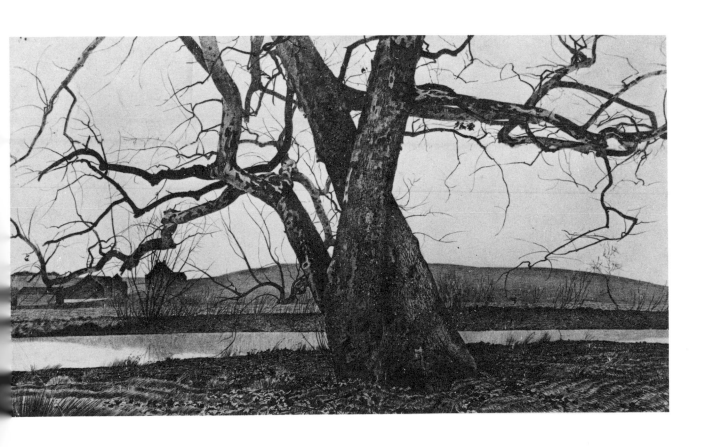

OGDEN PLEISSNER
Pen and Wash Drawing

OGDEN PLEISSNER won recognition as a watercolorist at an early age and since then honors and awards have piled up. He has an acute eye and an unerring hand to report his reactions to the visible world. This drawing, made with reed-pen and wash on a toned paper, is an excellent example of his extreme skill. The trees lining the roadway are drawn with an upspringing, sun-reaching quality that comes only to those who love trees and study them patiently.

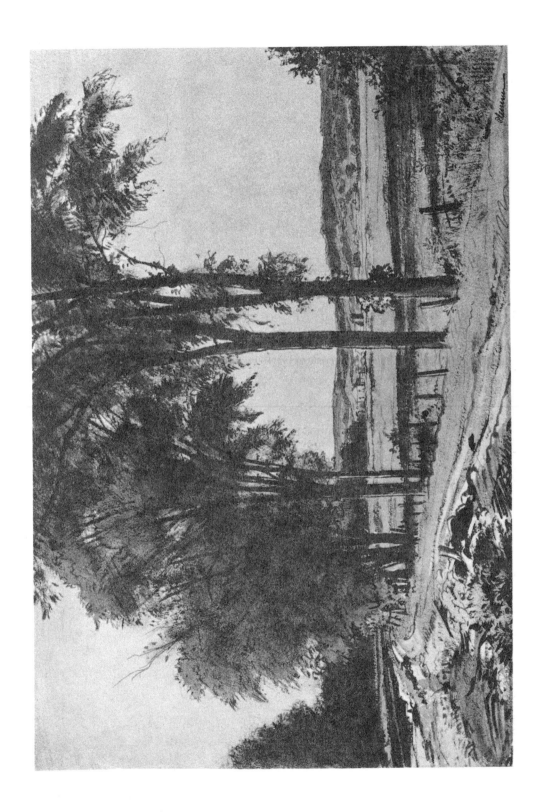

NORMAN KENT
Pencil Drawing

NORMAN KENT has had a versatile career as magazine and book editor, teacher, painter and printmaker. He has been a prolific sketcher from nature and this rapid and lively sketch is typical of the material in his bulging portfolios. It was drawn with a 2B pencil on media paper and is an excellent example of how much information about the form and light and flavor of a sunny day can be packed into an hour's work.

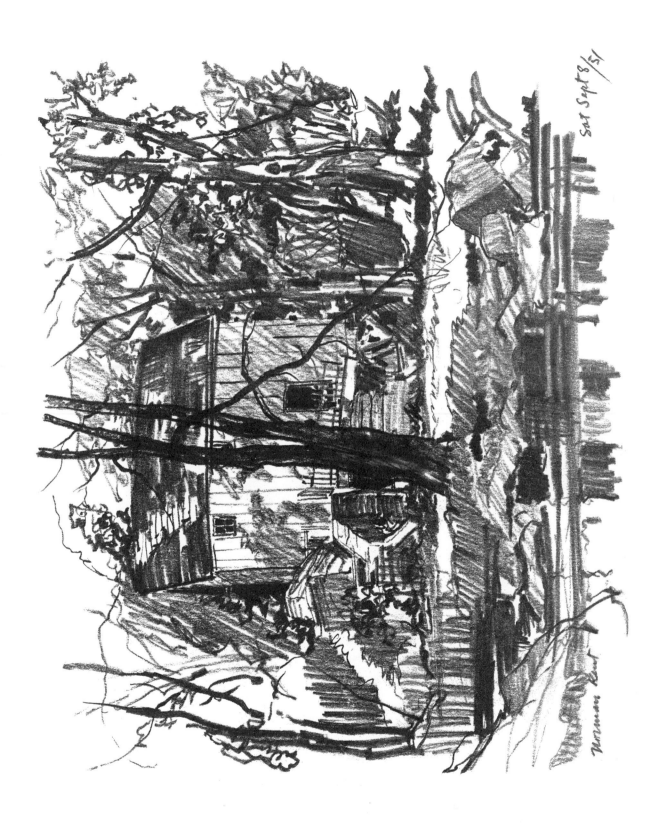

LYLE JUSTIS
Pen Drawing

LYLE JUSTIS is an artist of the pen whose work has always been
the admiration of his fellow artists. His pen pictures are "writ-
ten" with a directness, verve and delicacy that have had few equals.
This sketch of the early American forest looks as though it had
drawn itself. The pen has moved with rhythmic ease across the
paper, pausing for swift jottings of significant detail and then
moving on through shimmering areas of leafage, until a landscape
of breadth and depth has been suggested with seemingly noncha-
lant facility.

ERNEST WATSON
Pencil Drawing

ERNEST WATSON has occupied an influential position in American art through his many years as former editor of AMERICAN ARTIST magazine and through the many books on drawing, painting, perspective and illustration which he has written or edited. He is also a creative artist in his own right, a draughtsman who is particularly knowledgeable about the forms of nature. This is very evident in his delicate but vivacious pencil drawing of a dead tree. It was executed on heavy cameo stock with some sensitive white lines removed by the corner of a razor blade.

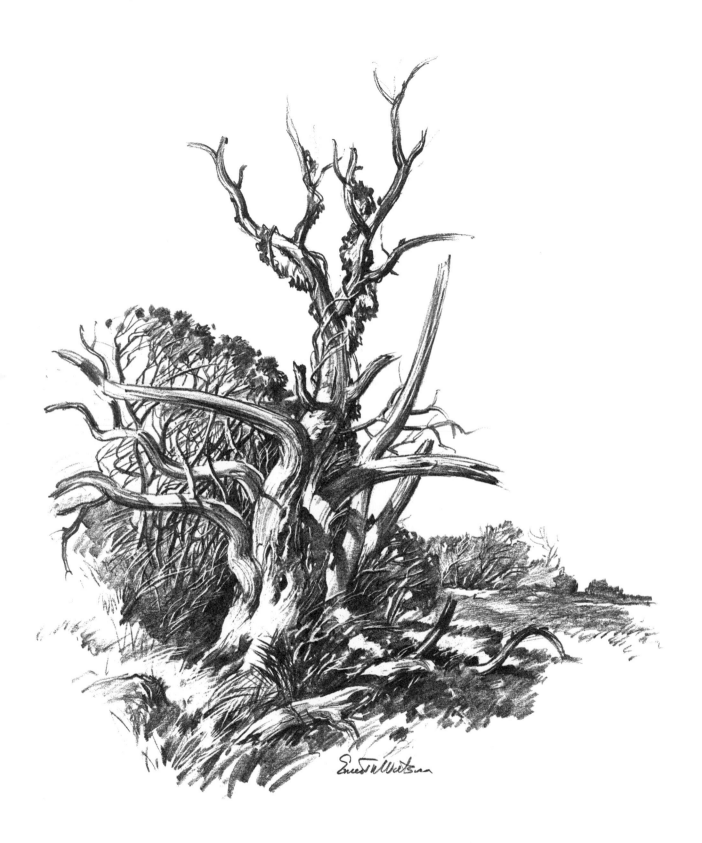

TED KAUTZKY
Southern Swampland

TED KAUTZKY, at the time of his death in 1953, was one of the best known of our landscape watercolorists. His books on watercolor painting and pencil drawing have been deservedly popular. He had great skill with the pencil. This study, executed with the broad edge of a soft pencil is a complete tonal statement of an interesting effect of light on sluggish water and mud flats, yet the brisk pencil attack never falters from beginning to end. This facility comes only when the artist knows exactly what he wishes to do.

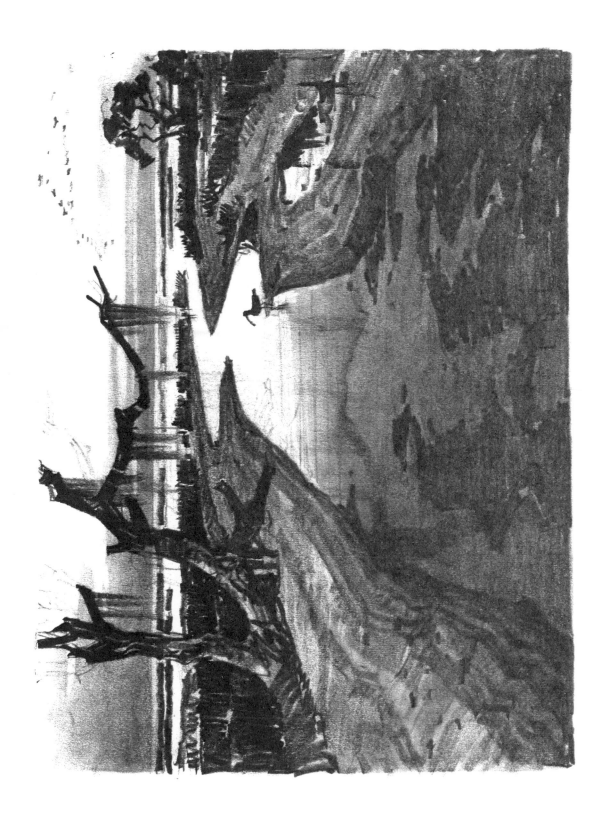

CLAUDE LORRAIN

Pen and Wash Drawing

CLAUDE LORRAIN (1600 - 1682) lived a long and prolific life. A native of Lorraine, he found in Rome and the nearby countryside the material for the long series of landscape paintings and drawings that made him famous. A portfolio of reproductions of his drawings is something to study and treasure. Like the drawing here reproduced they are usually executed in pen line and brown wash. His tree masses are nobly shaped. His knowledge of what infinite transformations shifting sunlight can work upon tree, rock and earth forms is available for the eager student to scrutinize and assimilate.

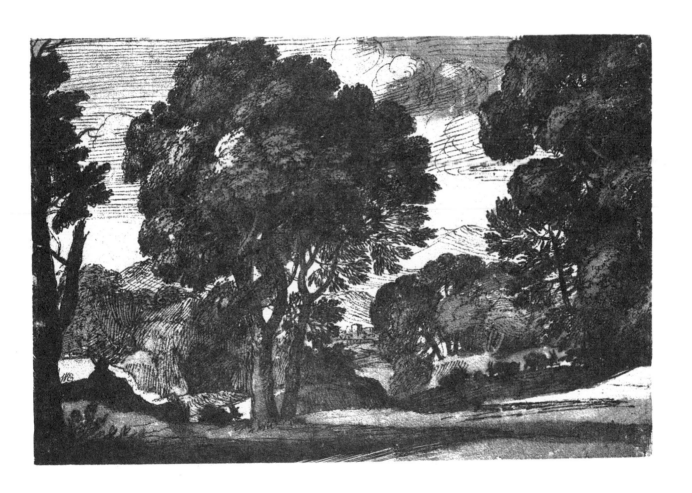

153

CARL PHILLIP FOHR
Heidelberg at a Distance

CARL PHILLIP FOHR was one of those minor artists whose very limitations are refreshing. He belonged to a large, starry-eyed company of youthful German artists of the early 19th century who were fired by the bright promise of the Romantic movement. They tramped the countryside entranced with nature, sketchbook in hand. This drawing, done with loving care, is a graceful record of an outdoor day.

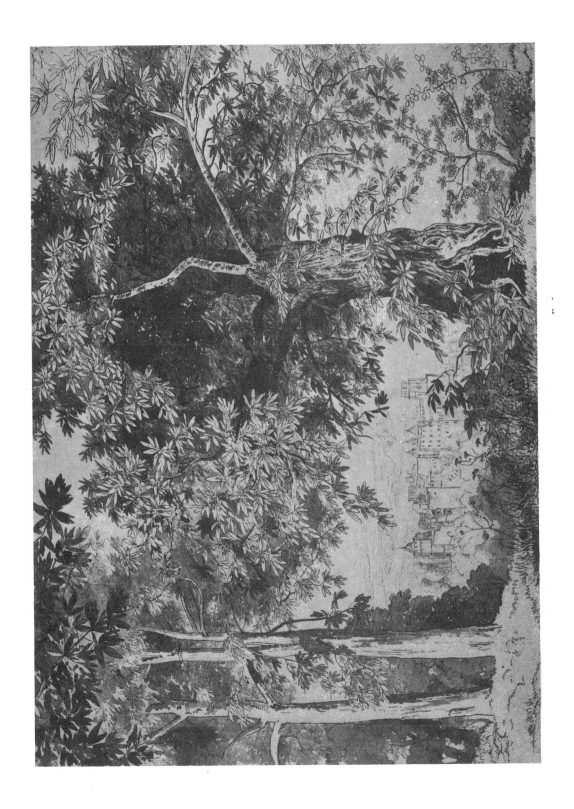

A. WATERLOO
Pen Drawing

A. WATERLOO (1607 - 1676) was one of the small figures of the prolific Flemish school. This reed-pen drawing, done in brown ink of varying strength, is an excellent example of how the 17th century artist looked at nature and translated her tree forms into pictorial conventions. Every age works out its own conventions and obviously those of the present day are different from those of the past, but it is well to realize that no convention dies because of age. Artists are constantly studying the conventions of the past to discover worthwhile things that have been forgotten or neglected by the present generation, intent on contemporary conventions.

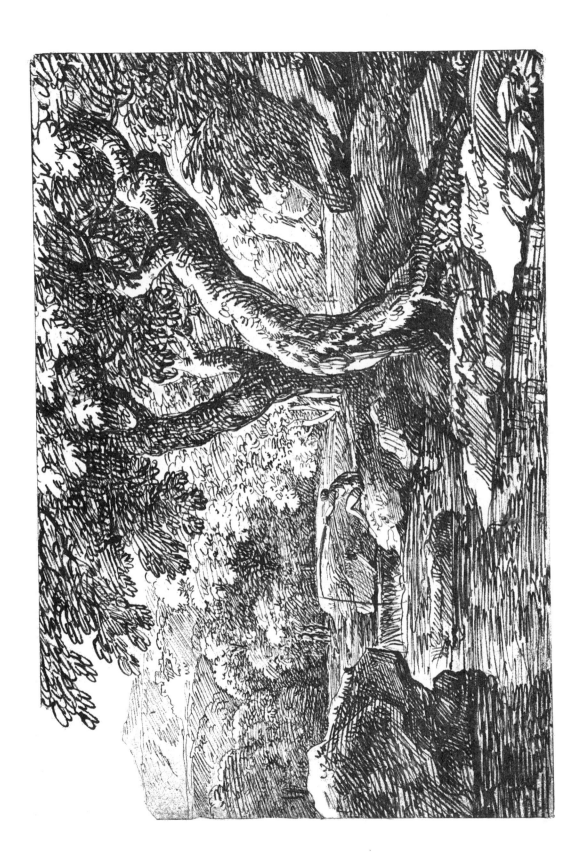

157

A List of Selected Books

Below are listed some books which can be recommended to the artist who wishes to enlarge his knowledge of trees. All are richly packed with information, presented in an interesting fashion. All, too, even the cheapest, are worthy to be kept on the shelf for permanent reference.

A POCKET GUIDE TO THE TREES by Rutherford Platt;
New York, Pocket Books, Inc., 1953.

A small paper-bound book for the pocket at a minimum price. Filled with brief and lively descriptions of all the important American trees, supplemented with excellent full-page photographic illustrations and line drawings of details. If one's tree library is to consist of only one book, this is a very satisfactory answer.

OUR TREES : HOW TO KNOW THEM by Arthur I. Emerson and Clarence M. Weed; Garden City, N. Y., Garden City Books, 1948.

An excellent guide for the amateur. Short, to the point descriptions of each variety, accompanied by full-page photographs of the entire tree, together with details of leaves, blossoms, seed vessels etc. One of the best books for quick reference.

TREES OF THE EASTERN UNITED STATES AND CANADA
by William M. Harlow; New York, Whittlesey House, 1942

A good pocket size book for the beginner. Excellent illustrations and accurate descriptions in nontechnical language.

MANUAL OF THE TREES OF NORTH AMERICA
by Charles S. Sargent; Boston, Massachusetts, Houghton Mifflin Company, 1933.

A large, authoritative volume for those who wish to study all the details of all the species. Many excellent line drawings.

OUR FLOWERING WORLD by Rutherford Platt;
New York, Dodd Mead & Company, 1947.

The dramatic story of the evolution of our plant life through the ages. This book will hold the attention of anyone who has the slightest interest in trees and will provide him with an understanding of why plants look and behave as they do.

THIS GREEN WORLD by Rutherford Platt;
New York, Dodd Mead & Company, 1943.

A remarkable book for arousing wonder and curiosity about plant life. It also satisfies the curiosity it arouses, for it is packed with information and explanations. It is fully illustrated with excellent photographic illustrations and diagrammatic drawings.

THE ARTISTIC ANATOMY OF TREES by Rex Vicat Cole;
Philadelphia, J. B. Lippincott Co., 1915.

To my knowledge, the most encyclopedic book written on the artistic attitude toward trees. Written by an English artist, it naturally deals with British trees, but they do not differ greatly from those of our northeastern section. This book is out of print but is worth hunting for in the second hand book stores.

OUTDOOR SKETCHING by Ernest W. Watson;
New York, Watson-Guptill Publications, Inc., 1946.

Deals with the basic problems of outdoor sketching, with emphasis on pencil and charcoal techniques.

PAINTING TREES & LANDSCAPES IN WATERCOLOR
by Ted Kautzky, N.A., New York, Reinhold Publishing Corporation, 1952.

Tree forms in landscape in the technique of watercolor.

PEN, BRUSH AND INK by Henry C. Pitz;
New York, Watson-Guptill Publications, Inc., 1949 (out of print).

Contains a chapter on tree forms for those whose interest is in the techniques of pen, brush and ink.

PENCIL DRAWING: STEP BY STEP by Arthur L. Guptill, F.R.S.A.,
New York, Reinhold Publishing Corporation, 1949.

Deals with all kinds of pencil and crayon techniques with a good chapter "On the Representation of Trees."

Designed by Norman Kent
Set in 10 point Times Roman
Printed and bound by Interstate Book Manufacturing Co.